The Drawings of Milton Avery

Burt Chernow

with a Foreword by Sally Avery

Taplinger Publishing Company, New York

First printing
Published in 1984 by
Taplinger Publishing Co., Inc.
New York, New York

Copyright 1984 by Burt Chernow
All rights reserved
Printed in the United States of America
Design by Laura Ferguson

Library of Congress Cataloging in Publication Data

Chernow, Burt.
 The drawings of Milton Avery.

 1. Avery, Milton, 1885–1965. I. Avery, Milton,
1885–1965. II. Title.
NC139.A93C5 1983 741.973 83-9245
ISBN 0-8008-2298-6
ISBN 0-8008-2299-4 (pbk.)

Acknowledgments

Given Milton Avery's productive nature, any limited selection of his work can only partially suggest the scope of his accomplishments in drawing. Every effort was made to represent a cross-section of his wide-ranging interests and a sense of the adventurous spirit he brought to his art. I am grateful to Grace Borgenicht Gallery, Alpha Gallery, Donald Morris Gallery, Andrew Crispo Gallery, Fox Gallery, Solomon Gallery, Gertrude Stein Gallery, Associated American Artists, Connecticut Fine Arts, Christie's, Milton Avery Trust, and a number of private collectors who generously lent works or provided photographs. Particular thanks to Susan Cooke and Barbara Haskell of the Whitney Museum of American Art, who were of great assistance in providing photographs and giving me access to research materials. Haskell's thorough book about Avery not only established his accurate year of birth but also shed light on his early development, clarified the chronology of events in the artist's life, and gave insight into his work. Finally, I would like to express my sincere gratitude to Sally Michel Avery for her time, ideas, and enthusiastic support in assembling much of the material used in this book.

B.C.

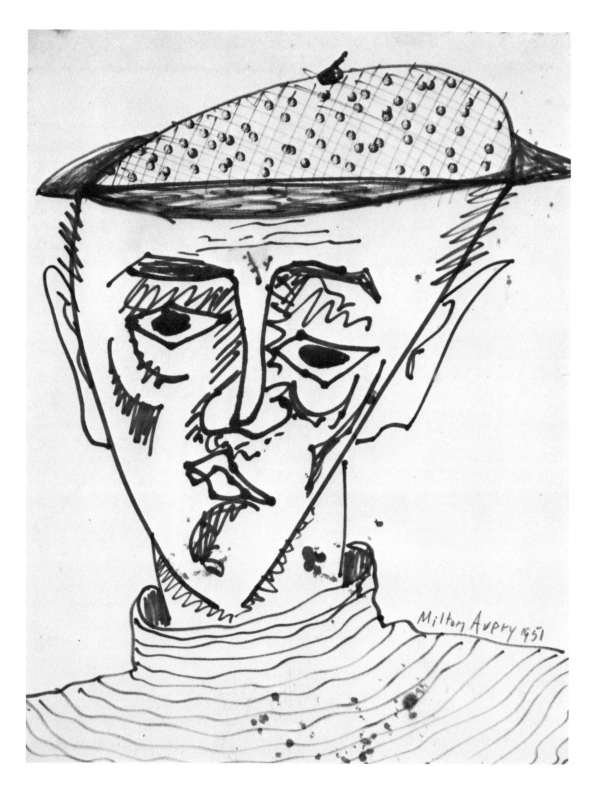

1. *Avery with Beret*

Drawing for Milton was as natural as breathing. It was part of the woof and warp of everyday living.

Drawing began at breakfast with doodling on the morning mail. I would sit across the breakfast table watching as strange heads, animals, and mythical landscapes appeared on the backs of unopened envelopes. These were scraps to treasure.

Friends who dropped by were always subjects. While we chatted, Milton sketched. I remember Suzanne who came with her little dog, bringing a new hat she had made for me. For Milton she became "The Milliner," "Woman with Dog," and "Seamstress."

Then there were the weekly sketch classes that continued throughout Milton's life. These moved about . . . first in our house when March was small and we couldn't leave her. Then later at Ike Muse's, after drawing the model in his studio for three hours, we gathered around the piano in his living room and listened as Ike played his guitar and sang old ballads. A favorite was "My Name Is Sam Hall and I Hate You One and All." We all joined in the chorus, and Willard MacGregor accompanied on the piano. Sometimes afterward there would be tea and cookies.

In the summertime there were long walks in the country in Connecticut, New Hampshire, Maine—wherever we were spending the summer. We sketched the hills and plowed fields. We followed the cows to pasture, drawing them endlessly. Summer by the sea produced lounging figures, beach umbrellas, and crashing surf, some to appear later as magnificent watercolors and oils.

All through Milton's life the importance of direct confrontation with the object was paramount. Coordinating the eye and hand was significant. Milton would say, "When I draw I am like a singer practicing his scales. It is a way of keeping my eye and hand ready for whatever demands I choose to make."

Sally Avery

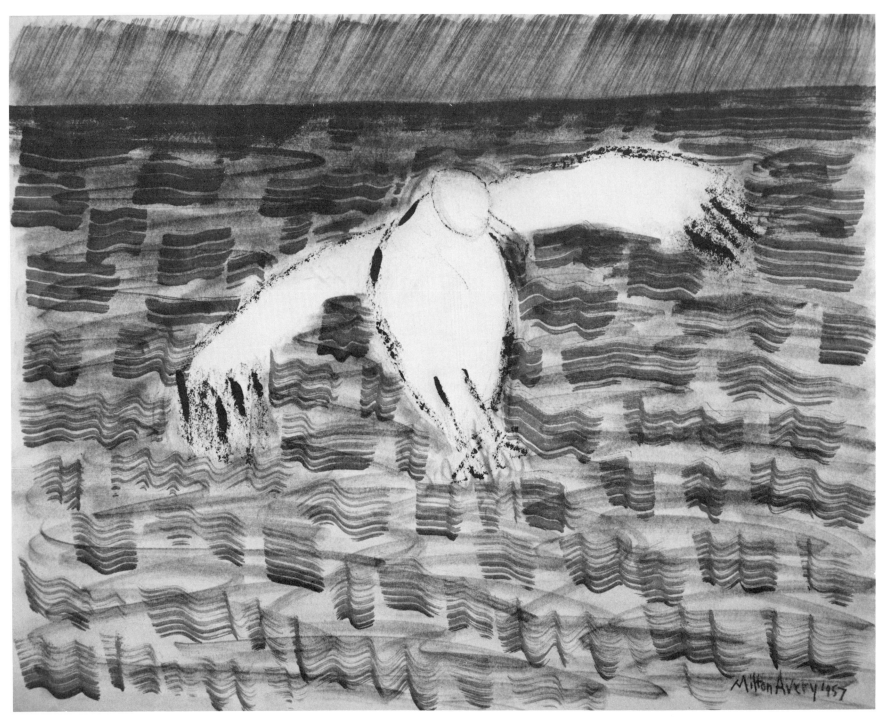

2. *Drifting Sea Gull*

There is no better introduction to Milton Avery than the frequently quoted Memorial Address delivered January 7, 1965, by the painter Mark Rothko. He said, in part, "Avery is first a great poet. His is the poetry of sheer loveliness, of sheer beauty. Thanks to him this kind of poetry has been able to survive in our time. This alone took great courage in a generation which felt that it could be heard only through clamor, force and a show of power. But Avery had that inner power in which gentleness and silence proved more audible and poignant." Rothko went on to say, "There have been several others in our generation who have celebrated the world around them, but none with that inevitability where poetry penetrated every pore of the canvas to the very last touch of the brush. For Avery was a great poet-inventor who had invented sonorities never seen nor heard before. From these we have learned much and will learn more for a long time to come."[1]

For Milton Avery, as for many other artists, recognition was that slow-riding messenger that was certain to arrive late, if at all. His role in the development of twentieth-century American art was among the most crucial and, until recently, most misunderstood in our time. Younger artists such as Mark Rothko, Adolph Gottlieb, and Barnett Newman were deeply indebted to him. They learned from Avery's work even when it appeared unfashionably abstract to an art world dominated by realists in the 1930s. They found in his quiet commitment and courageous example a clear alternative in which realism and abstraction were not adversaries, but essential partners. They continued to learn from his art during the postwar period, when Avery's painting was critically misread as offbeat realism, apparently not abstract enough for the current taste. At one point during the 1940s the director of the Museum of Modern Art, Alfred H. Barr, Jr., asked Rothko who he thought the great American artists were. When

Rothko proposed Avery's name, Barr laughed.[2] These divergent opinions reflected Avery's precarious position. Although Barr and some other observers had a problem in coming to grips with Avery's work, Rothko and other painters might not have progressed without its precedents. As Rothko, Gottlieb, and Newman played increasingly important parts in the ascent of Abstract Expressionism, Avery experienced a growing isolation. This unassuming artist from whom so much had been learned was again treated by a capricious art world with the benign neglect he had received in the past.

Milton Avery disregarded shifting dogma and aesthetic polemics; he simply painted. Single-mindedly he fashioned a pastoral world that can be measured by what it gave and what it denied. There was no place in his art for the anxiety of urban life; there were no machines, no massive city structures, no storms, no winter landscapes, no illness, and no death, only a genial, friendly world of leisure. There is love in the many images of his wife Sally and their daughter March, affection in his animal subjects, and warm acceptance in the landscapes and seascapes. Few artists can take jagged rocks or large waves and make them as inviting as Avery does. Robert Frost wrote, "We love the things we love for what they are," and there is this sense of willing affirmation in the artist's work. Avery evokes an atmosphere of shared intimacy where realism and abstraction intersect. His art is often tranquil, occasionally monumental, and always inventive. It addresses life, and is most moving when seen against the foil of a troubled twentieth century. Avery lovingly accepts the human condition and the world, and we cannot help but do the same when we see them through his eyes.

With the passage of time, Milton Avery's reputation continues to grow while his pivotal place in the history of modern art has become more apparent. A significant reassessment of Avery's work began just

prior to the opening of his 1982 retrospective exhibition at the Whitney Museum. Hilton Kramer, author of the first book about the artist,[3] wrote a widely read article that was featured on the cover of the *New York Times Magazine*. Kramer ventured several judgments that surprised and gave pause to some art historians. He observed, "In my view, his late paintings represent a more impressive achievement than Rothko's, for they encompass a far greater range of experience and bring to it a subtler and more varied pictorial vocabulary." He also concluded that "Avery has the finest eye for color in the entire history of American painting."[4] Articles like Kramer's, Barbara Haskell's catalogue for the Whitney exhibition,[5] and particularly the paintings themselves, which later traveled to five other locations, have permanently changed the art history of our time. While Avery's achievement is still largely absent from or plays only the smallest part in most current textbooks on American art, the revisions have started. The new generation of survey text writers have finally found sufficient grounds to recognize Milton Avery's real contribution.

If Avery is acknowledged to be one of the great colorists of this century, why then a book about his drawing? To understand Avery's color is to understand only part of his work, for drawing is central to his color and offers a direct path to the core of his artistic concerns. He was an outstanding draftsman who recognized that the act of drawing was inseparable from painting. For Avery, drawing was a daily celebration of life. It was his ongoing visual diary, a quotidian means for giving form to his inner vision and to the life force he felt in everything he experienced. Avery sheared away fussy details in an attempt to get to the heart of each subject. His graphic works have the fresh and effortless finality we have come to expect from his painting. He created a personal language of drawing and then went on to produce paintings not only with color but also with that elusive quality of light. Adolph Gottlieb once called Avery "a brilliant colorist and draftsman,"[6] recognizing the interdependence of these concerns. Gottlieb knew that drawing was the precise tool that Avery used to make each expressive subject dramatically concise. It is difficult fully to understand Avery without knowing what drawing meant to him and how the matter-of-fact economy of his drawing united the elements in his art.

Taken together, Milton Avery's drawings represent a tour de force that is one of the artist's least known accomplishments. His drawings are infrequently exhibited in depth by galleries or museums. For example, none were included in his 1982 retrospective at the New York Whitney or the concurrent exhibition at the museum's branch in Stamford, Connecticut.[7] It is therefore not surprising that the general public is either totally unfamiliar with the artist's drawings or has an impression based only on the most fragmentary evidence. Avery's drawings are the lifeblood of his art and in fact the direct subject of each painting. They offer the most accurate, least modified view of Avery's first vision, giving us the sharpest focus on his creative efforts.

Avery was one of those very rare artists who learned to trust his own intuition completely. His aversion to anything overworked was matched only by his gift of knowing exactly when to stop. He would say, "It takes two artists to make a picture. One to do it and one to tap him on the head when it's time to stop."[8] What makes his drawing so alive was his willingness to take risks. Every movement of the pencil, pen, or brush was an adventure. He said, "In order to paint one has to go by the way one does not know. Art is like turning corners: one never knows what is around the corner until one has made the turn."[9]

Not every Avery drawing was successful. For him, drawing was an exciting event more than a search for perfection. It was an opportunity to get closer to the subjects he cared most about. Because of his large production and continuing inventiveness, there is some unevenness in the drawings, as there is in the paintings. When another artist does five or ten paintings a year and a correspondingly small number of drawings, avoiding the risk that comes with breaking new ground, the work will certainly be more even. In Avery's work we often encounter a refreshing element of humor or, more accurately, lightheartedness. He consistently chooses modesty and visual wit rather than purely decorative solutions. His linear structure and his ascetic use of two-dimensional shapes has its own internal logic and whimsical contour that set his art distinctly apart from that of any other artist.

The fact that Milton Avery's work holds up as well as it does suggests a far more complex visual enterprise than is indicated by much of the writing about the artist. The elusive qualities that breathe marvelous life into an Avery drawing or painting are indeed the result of something more complicated than his use of low-key colors, reduced forms, or any number of other frequently cited strategies. Yes,

Avery brought together abstract and figurative elements; yes, he was able to merge innocence and sophistication; and yes, he had a powerful impact on several generations of American artists; but he remains far more enigmatic than his very approachable visual statements would suggest. Perhaps it was what Clement Greenberg referred to as his sheer "force of feeling"[10] that eludes any satisfactory analysis. Sally Avery often recalls the comment of the noted French art dealer Paul Rosenberg: "Milton Avery paints the way a bird sings."[11] With a complete disregard for critical theories Avery found ways to draw and paint his private vision with the clarity of a bird's song.

It could be said that in a typical Avery drawing, every little thing is wrong, yet the whole thing is right. If others would sacrifice the soul of a subject in order accurately to portray its parts, then Avery could enlist distortion to reveal the truth of the whole. A tireless worker, he produced many thousands of drawings throughout his career. Some of the drawings have been lost, and others were destroyed by the artist, but Sally Avery has preserved and organized a great number from every period. They constitute a remarkable autobiographical record of Avery's evolution as an artist. Animals, figures, portraits, landscapes, and seascapes in turn chart each hazardous turn in the road and give insight into his very special way of looking at the world.

The task of giving titles to the drawings was always left to Sally, with Milton saying, "It's enough that I have to do them."[12] Today she delights in poring over them, remembering with amazing accuracy the exact time, place, person, or experience in question. Some of the drawings are framed and hang beside his watercolors and small oils; others are in envelopes and portfolios on shelves; and still others are stacked in file and blueprint cabinets. It would take an afternoon to go through a single drawer in a standard letter-size file cabinet. In one such drawer there were thirteen envelopes containing hundreds of small early drawings separated by subject: nudes, single figures, portraits, mother and child. In the same drawer were over thirty neatly arranged sketchbooks, some small enough to fit into a pocket. There were school-type notebooks filled with typical sketches, spiral-bound pads occasionally with several drawings on a page, and even a small autograph book with every page a different color.

What kind of man produced this body of work? Avery was a quiet man with a gentle disposition. Asked if Milton was as gentle as his visual language, Sally responded with great seriousness, "He never said a mean word in his whole life." He had no interest in politics, art organizations, manifestos, or doctrinaire formulations. When asked about his religion he would reply, "Art is my religion."[13] His dedication to art was absolute, with no separation of art from life, yet in spite of his intense commitment he could always poke fun at himself. In a footnote to her catalogue, Haskell illustrates his deadpan humor: "Avery's doctor announced that he planned to take up painting when he retired. 'When I retire,' Avery responded, 'I'm going to take up medicine.'"[14]

"Milton Avery lived and worked as if to avoid biography," writes Haskell. "He left no significant autobiographical remnants. He wrote virtually nothing; participated in no organizations; and spoke with such reticence that scant oral testimony was recorded. 'Why talk when you can paint?' was his oft-quoted remark."[15]

During the first half of his life, almost forty years before meeting Sally Michel, he held a succession of low-paying jobs along with an extended, very conservative art education. In the next forty years this quiet man, freed from the burden of having to earn a livelihood, produced one of the largest, most impressive bodies of work in modern times. The youngest of four children, Milton Clark Avery was born in upstate New York in 1885. His father Russell, employed as a tanner, and his mother, Esther March Avery, were descended from early eighteenth-century English immigrants. Milton had to begin working in nearby factories when he was sixteen years old. Later he attended classes at the Connecticut League of Art Students in Hartford while working at one blue-collar job after another. With the death of his brother-in-law in 1915, Avery became the only remaining adult male responsible for the support of nine female relatives in his household. Four years earlier in 1911, in spite of his grim economic situation, he listed his occupation as "artist." Even as his circumstances grew worse he continued to pursue his art interests while working at whatever jobs were available. In 1918 he entered the School of the Art Society of Hartford and in the following year won the ten-dollar first prize in his drawing and portrait classes. These were straightforward academic works in no way related to the now familiar Avery images.[16] In 1920 he visited Gloucester for the first of what would be many summers of drawing and painting. There in the summer of 1924 he

met a young woman from Brooklyn named Sally Michel. This proved to be the turning point in his life.

Since the middle of the nineteenth century Gloucester had attracted many painters. Winslow Homer, John Henry Twachtman, Childe Hassam, Marsden Hartley, John Sloan, Stuart Davis, and Edward Hopper were just some of the artists who found inspiration there. Several years before Avery began to make his regular pilgrimages, there were so many artists around the town that John Sloan was prompted to state, "There was an artist's shadow beside every cow in Gloucester, and the cows themselves were dying from eating paint-rags."[17] In discussing the summer of 1924 when she met Milton, Sally recalled, "Everybody was an artist." Abraham Walkowitz was one of many painters she saw working around the port that summer. Sally had rented a partitioned sail loft studio next door to one provided rent-free to Milton by the muralist Frederick L. Stoddard, an early supporter of his. One day Milton invited her into his studio to see his work. Sally remembers being impressed by a small Impressionistic oil painting of a girl's head in blues and yellows that was on the easel. She recalls thinking, "He could teach me a lot," and accepted an invitation to dinner. In the days that followed they sketched together on the rocks, swam, painted beside each other on the shore, took a bus ride to Rockport where they did drawings, visited artists they knew, and often walked together to the Gloucester docks at night to watch the fishing boats return.

In 1925 Stoddard's offer of free living quarters and studio space on Staten Island made it possible for Milton to come to New York. Avery was forty at the time but had misrepresented his age by eight years to appear a more acceptable suitor for a younger woman. It was not until 1982 that Haskell's research established 1885, not 1893, as his year of birth. Finally in May 1926, after considerable courtship and over the objections of Sally's Orthodox Jewish parents, the couple decided to marry. They were wed in a Brooklyn courthouse with only Wallace Putnam, an artist friend, and Sally's sister present. From the beginning Sally was determined to free Milton from the meaningless jobs that had thus far frustrated his need for a total involvement with art. Her unflagging belief in his potential carried them through many dark years during which she provided all of their financial support by her work as an illustrator. At last he would be able to concentrate on his art

and their marriage proved to be one of the most remarkable in art history.

New York City, like Sally, would have a decisive effect on Milton's art. Despite its vitality and its many crosscurrents, the city was hardly receptive to modernism in 1926. Alfred Steiglitz had by this time closed his legendary 291 Gallery, which supported such early American innovators as Arthur Dove, Marsden Hartley, and Georgia O'Keeffe. Experiments related to European modernism were almost entirely abandoned, and the dominant trends were Realism, Social Commentary, and American Scene painting. Even with its relatively conservative tempo, New York was electric compared with Hartford. Milton's work had progressed from academic sketches done from plaster casts in Connecticut classes to his current thickly painted Impressionist work influenced by Robert Lawson and John Twachtman. In the middle 1920s Avery's painting was usually done directly from nature. By the late 1920s, however, a fundamental change had taken place in his working procedure, a change that subsequently made his drawings increasingly important. From this point on, his paintings were done directly from sketches; in effect Avery's drawings became nature's messengers to the paintings, which might be done hours, days, or even years later. Throughout his life Avery said, "Nature is the greatest teacher."[18] He would select a particular drawing, tack it to the easel, and begin painting. The radiant oils and watercolors that emerged would grow out of the artist's memory coupled with the fresh first vision initially captured in the act of drawing. Albert Pinkham Ryder, one of the artists Avery most admired, once said, "It is the first vision that counts. The artist has only to remain true to his dream and it will possess his work in such a manner that it will resemble the work of no other man—for no two visions are alike."[19]

Addicted to drawing, Avery often did several sketches before his first cup of coffee in the morning. Even in his drawings of the late 1920s (plates 12, 13, 14, and 15), his graphic sensibility seems to grasp for the essentials of each subject. It was not just simplification or empathy, but a never-ending struggle to join his efforts with the extraordinary content he had discovered. "Their entire lives revolved around art," wrote Haskell. Starting in the morning, "they would often draw or paint straight through until dinner." Avery "read from

cover to cover every art magazine he could find, and he and Sally spent every Saturday going to galleries and museums."[20] One of the most important activities for the couple was attending regular sketch classes at the Art Students League, where they drew from live models at daily uninstructed sessions. "We could not afford the theater or movies, but sketch classes cost five dollars a month and we went almost every evening," said Sally. For the first twelve years of their marriage, from 1926 until 1938, they religiously attended these figure drawing classes.

During these years there was often little money for either food or art supplies. Many of the drawings of this period are done on the back of used stationery, envelopes, announcements, and advertisements of every shape and color. They were able to buy paper at a 40 percent discount from Adolph Gottlieb's father, who owned a wholesale stationery business. Forty cents would pay for a package of one hundred sheets of black construction paper, which they then cut and used for gouaches. A ream of five hundred sheets of bond typing paper provided quantity at an affordable price. With the exception of the sketches done on odd-size scraps, almost all of Avery's drawings are two sizes. The small size is 8½ by 11 inches, the standard-size typing sheet. The larger drawings are 14 by 17 inches, the size of the sketchpads used in the figure drawing classes. It is not unusual to find two or more very full studies on a page or on a sheet of the smallest sketchbook.

With the birth of their daughter March in 1932, Milton found a subject that he would explore inexhaustibly for the rest of his life. He did hundreds of sketches of his daughter and Sally in 1932 and 1933, six of which (plates 16–21) are reproduced here. His first retrospective exhibition at the Durand-Ruel Gallery in 1947, entitled My Daughter, March, was proof of his gentle, continuing visual interrogation. When March was six years old, the family moved to an apartment in Greenwich Village, and Milton and Sally stopped attending classes at the Art Students League. Instead they organized weekly sessions at their home and at the homes of George Constant, Byron Browne, and other painters. Usually five to seven artists came, with sometimes as many as ten present. It was a cooperative venture with everyone sharing the expense of the model. The session usually lasted three hours, from 7:00 to 10:00 P.M., with Milton often completing as many as thirty drawings. The model took a five-minute break every half-hour, and there was always a businesslike tone to the work that everyone was engaged in. Coffee and discussion usually followed each session. In varying circumstances, for over forty years until 1960, Avery routinely attended figure drawing classes.

When asked why the figure was so important, Sally responded, "The subject of his drawing was not the object of his drawing," adding, "it could have been anything. The idea was to develop eye-and-hand coordination and maintain the immediacy of his subject." While regular participation in sketch classes was an expression of Avery's

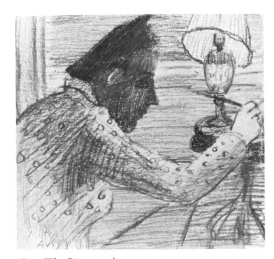

3. *The Letterwriter*

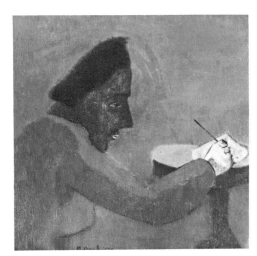

4. *Woman with Green Face*

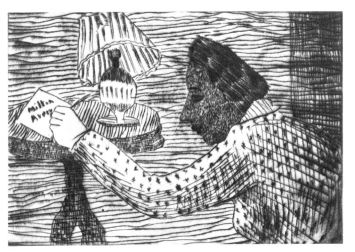

5. *My Wife Sally*

workmanlike approach to art and his figure studies represent a large portion of his work, almost all things were fascinating to him. Sally recalled that everything was his favorite subject. He was not driven, but enjoyed the friendly confrontation with life that frequent drawing provided him with. Though the subject matter was usually ordinary, through some particular kind of magic, Avery's nudes, trees, or rocks become extraordinary, and we are left with the feeling that perhaps we never really looked at these things before. Could "ordinary" be nothing more than the wonders of life not seen through an awakened eye?

Avery's art remained true to what he felt about the real world, his world. If design, distortion, or pattern ever threatened the truth, it was the truth that prevailed in the work. He said, "I work on two levels. I try to reconstruct a picture in which shapes, spaces, colors form a set of unique relationships, independent of subject matter. At the same time I try to capture and translate the excitement and emotion aroused in me by the original idea."[21] In examining the large body of drawings and numerous sketchbooks produced by the artist, what comes through is Avery's sure touch, his wit, his concise and active line, and, despite all distortion, his fidelity to his subject.

He could remain loyal to his subject matter while at the same time being curiously detached. Avery's objective positioning to the specific motif along with his total commitment to art could not fail to impress the artists who knew him. His attitude and integrity set an example that encouraged others to continue what often seemed like a losing battle. Writing about this period, Sally Avery said, "The art world was smaller then. For us there were no cocktail or dinner parties. Life revolved around painting, talking about paintings, looking at paintings. We saw each other day in and out. We spent summers at the same country and seaside places. Evenings we'd gather to have a cup of tea and look at our day's work. There was no talk of selling—only of painting. The chance of commercial success was so improbable that it never entered into serious discussion. We talked of painting ideas, about painters good and bad, young and old. It may seem dull by today's standards, but it never was."[22]

Milton and Sally were a warm and giving couple in spite of their persistent financial hardships. Artist friends regularly dropped by to discuss art or just socialize. Marsden Hartley, a friend and longtime advocate of Milton's work wrote, "Avery is never bitter, he is never the over-wrought ironist, because I suspect life for Avery is a very simple affair; it is what it is for the artist, and when he realizes he is caught within the web of his own childish dreams, he learns that he is inevitably his own sort of poor fish, and there is nothing to do but follow the 'inscape' of it."[23]

Certainly Sally Avery was one of the reasons Miton was never bitter. She was not only his wife who provided financial support throughout his life, but equally important she was an artist and an articulate spokesperson for his position as an artist. When asked how she influenced his gradual transition from early academic roots to modernism, Sally thought for a moment and smiled, saying, "With approval for the more daring things." She added that by the 1930s Milton was feeling happy, gaining confidence, growing artistically, and believing that he would "let the paint tell him what to do."

Following the dictates of the paint Avery created *Woman with Green Face* (plate 4) in 1932. This work would seem to be a turning point in his development. More clearly than any painting that precedes it, *Woman with Green Face* signals the direction of his future production. Here, Avery reinvents Fauvist ideas and begins to use nonassociative color in his own way. Forms are flattened, and shape-making becomes a primary function. His preliminary drawing *The Letterwriter* (plate 3) done in 1931 with lithographic crayon on cardboard, provides the model for the painting. It also provides some insights into Avery's working process. The deliberately ungainly drawing with its apparently arbitrary shapes is transferred to the larger canvas rigidly adhering to the original structure and spirit. In simplifying, as Avery usually does when translating a sketch into a painting, the lamp, curtain, and pattern on the dress are eliminated. The related drypoint etching of 1934, *My Wife Sally* (plate 5), reverses not only the image but also the process by adding details and elaborate textural patterns.

Another interesting contrast can be seen in the sympathetic pencil study *Mark Rothko* (plate 7) done in 1933 and in the *Portrait of Mark Rothko* (plate 6) painted in the same year. Avery's technical ability is immediately seen in the drawing's free-swinging lines, which ripple with energy. Only the essentials are considered as the artist explores shapes rather than three-dimensional modeling. Avery's ability to rapidly and accurately enlarge a small sketch freehand on a larger

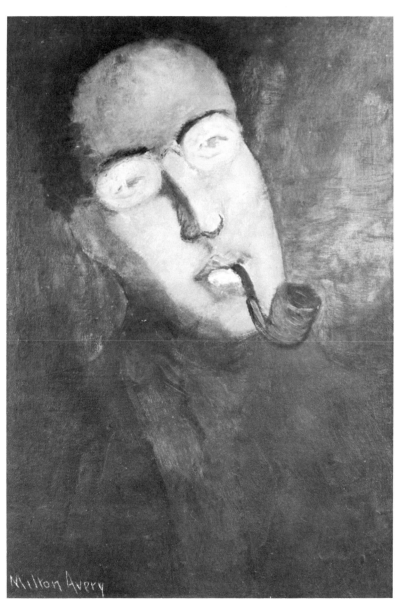

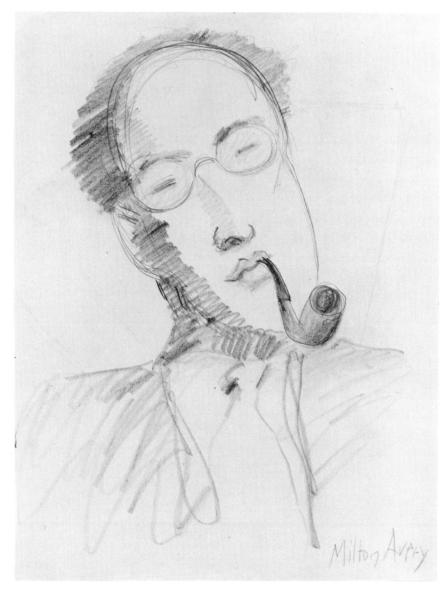

6. *Portrait of Mark Rothko* 7. *Mark Rothko*

canvas impressed both Rothko, who "hated to draw,"[24] and Gottlieb. They were both considerably younger and regular visitors interested in seeing Avery's latest work and talking to the man whom Gottlieb described as "a solitary figure working against the stream."[25] Avery's art ran parallel to his life, and any guest at his home would in short time become the subject of a portrait. For this reason a review of his drawings from any period provides an inventory of the people and places that made up Milton and Sally's life.

Avery's world was not without its games and recreation, and these supplied such subjects as cards, checkers, backgammon, pool, Ping-Pong, the circus, burlesque, vaudeville, and the beach. *Coney Island Sketches* (plate 36) of 1931 is the starting point for *Coney Island* (plate 35), an oil painting done two years later. Just as the brooding colors of Avery's early New York paintings gradually brightened, the caricature-like distortion of *Coney Island Sketches* became less pronounced in the decades that followed. The recurring theme of the beach initially brought out the journalist in Avery, with works like *Beach Studies* (plate 39) and *Man with Pipe* (plate 38), a sketch of Adolph Gottlieb seated on the beach at Gloucester. In these literal works as in the later more generalized interpretations, Avery's subject matter remains tranquil, but never becomes sentimental.

For many people, Avery's subject matter and style appeared to be out of touch with the hard realities of the depression years. Unlike other artists who focused on the bread lines of the thirties, Avery stayed with what Rothko called his "domestic unheroic cast."[26] During this period Avery's unself-conscious art was viewed as naive by a considerable portion of the art community. In 1932 one reviewer wrote, "These often grotesque and sometimes rather gruesome forms of his must mean something pretty definite to him."[27] They did, of course, and Milton occasionally observed to Sally and others, "Either I am crazy or they are crazy,"[28] referring to the values that ruled the American art scene in the 1930s.

His fortunes took a turn for the better in the 1940s. Sally started working for the *New York Times,* continuing to do her illustrations at home, and Milton's work began to generate some sales. In 1943 Paul Rosenberg became Avery's new dealer and annually purchased groups of twenty-five paintings from the artist. These purchases typified the European method of periodically acquiring some work from each artist associated with the gallery. Avery was fifty-nine years old when the Washington Phillips Memorial Gallery (now the Phillips Collection) gave him his first museum show in 1944. One year later both Rosenberg and Durand-Ruel, two of the best-known French modern painting dealers in New York, mounted simultaneous Avery exhibitions in their separate Fifty-seventh Street galleries. To many it appeared that Milton Avery was on the threshold of full recognition as a modern American master.

With the rise of Abstract Expressionism, Avery suffered from what Haskell correctly called a failure of "critical circumstance."[29] As luck would have it, Avery, excessively abstract in the thirties, was now too realistic for the new taste. The influential critic Clement Greenberg, for example, dismissed him as a minor figure. Avery's attitude as an artist did not change, but fourteen years later, Greenberg would reverse himself and reappraise Avery, saying, "That the younger 'anti-Cubist' abstract painters who admire Avery do not share his naturalism has not prevented them from learning from him any more than it has prevented them from admiring him. His painting shows once again how relatively indifferent the concrete means of art become where force of feeling takes over."[30]

Critical ups and downs, success or failure in the marketplace, seem to have had no effect on Avery's work. His primary concern was to make each painting better than the previous one. As well known as he had become in the 1950s, producing some of his finest work, he earned just fifty dollars in one year.[31] Sally speaks of his "dogged determination to let nothing distract him from his chosen task of revealing more and more of his private vision."[32] He gave good reviews as little attention as bad ones, since he had his own exacting demands to satisfy first. "If he despaired she would encourage him," wrote Chris Ritter, "and if that failed she would threaten to divorce him, saying that she didn't want to be married to a bad artist."[33] What the critics said, his reputation, the amount of money he earned—none of these mattered as much as the success of the current painting.

In the 1950s Avery produced some of the great paintings of this century. These late works stand comparison with anything done in America or Europe. As the pendulum of critical judgment swung from

one extreme to another, Avery remained in a self-imposed no-man's-land, somewhere between realism and abstraction. His steadfast course would not allow him to give up either the strength of his formal vision or the core of the subject being represented. Abstract art was "too easy."[34] The color and structure so vital to Rothko, Gottlieb, and Newman were without meaning for Avery unless they were integrated with the subject. From our perspective of time, there is no mistaking the consistency of Avery's priorities or his unbending artistic intentions.

In his work Avery searched for the same coherent order he saw in nature. There was nothing esoteric about his approach. "I strip the design to essentials," he said in a 1952 interview, "the facts do not interest me as much as the essence of nature."[35] The serenity to be found in the artist's work comes from his ability to be at one with his environment. "He never studied Eastern concepts or art, but he had an Oriental soul," Sally observed. However much he distilled a subject, it emerged structurally whole and in harmony with the rhythms of nature. His deceptively simple work was assembled from the most commonplace events of everyday life with what Kramer called "awesome concision."[36]

Because the Avery family was extremely close, their vision of life was understandably interconnected. All their lives Sally and March have been dedicated artists. The close relationship of their work to Milton's art is rarely discussed. Milton always encouraged Sally and thought her talented. Her illustrations of figures with featureless faces were not unlike some of Milton's drawings, and her paintings are close to his in spirit and substance. They often worked side by side, and it is not surprising that great similarities exist. March Avery, growing in a disciplined and art-saturated environment, was never told what to do or how to do it, yet she saw the world through her father's eyes. March's painting, with its unique character, is a counterpoint to her parents' related efforts. The interrelationships of the art produced within the Avery family offer an intriguing subject for future study.

Milton, Sally, and March made each summer a time for travel and fresh discovery. Summer was that magic time when Milton would accumulate a wealth of drawings containing seeds that would eventually flower into light-filled paintings. These drawings might be com-posed of just a few lines of calligraphic shorthand such as *Dune Grasses* (plate 81), or they might be fully developed pieces like *Artist's Daughter* (plate 23). Frequently color notations on the drawn images served as reminders for future paintings. To examine Avery's evolution as a draftsman is to review his summer travels. Each new summer experience introduced the renewed challenges on which Avery's graphic work thrived. His drawings were a chronicle of family travels and a record of those continuing sensations of visual discovery that Avery experienced.

From 1924, when Milton and Sally first met, until 1934 they spent most of their summers in Gloucester. In 1935 and 1936 they stayed in Vermont, and in 1938 they shared an inspirational and productive summer on the Gaspé Peninsula in Quebec. *Rocky Terrain* (plate 62) is one of the drawings done in this sparsely populated area. Avery was fascinated by the light in this region, and color references appear throughout the sketch. The drawing is totally unlabored, with the compositional elements reading as tightly organized flattened shapes. The concern here as in most of his work, is with surfaces, not volumes. In the summers of 1939 and 1940 the Averys returned to Vermont. It was about this time that the family agreed to get a dog. They named their new pet Picasso (plate 88) and took him along on a cross-country summer trip to California in 1941. Picasso was introduced by name to many people at various stops along the way. No one responded to the name until they reached California. "Oh, it's his black period," some-one said. "That's when I realized," Sally said with a smile, "how long it takes for an artist's name to become a household word." That summer Milton filled a tiny sketchbook with numerous studies, many of which later became watercolors and oils.

Gas rationing forced them to remain in New York in 1942, but the next three summers brought the family back to Gloucester where Rothko and Gottlieb were almost daily visitors. They spent the summer in Mexico in 1946, in Oregon and Canada in 1947, and in Maine in 1948. *Jagged Rocks* (plate 64) is a handsome double drawing done in Oregon. Avery was sixty-two when he executed this spontaneous and firmly controlled work. There are no inconsequential details, only the whole subject as if seen at a glance. *Nine Maine Sketches* (plate 8) is an important condensed series of studies, many of which were

later developed into major seascape paintings. Each of the compacted, serial-like boxes is intimate and very alive. Each demonstrates the artist's ability to capture the pulse of his subject. Despite their small size, there is a feeling of great internal scale in each panel.

Milton Avery worked with a wide variety of drawing tools including pencil, brush, charcoal, crayon, and ball-point pen with three interchangeable points. When the Flobrush was first introduced about 1946, Avery immediately adopted it and used it with great frequency. By 1946 the process of drawing was as effortless for him as thinking. The strength and fluidity of the Flobrush line had an obvious appeal to a man with Avery's temperament and talent. There was nothing safe about it. There were no Flobrush erasers, and Avery did not need one. Resulting drawings like *Jagged Rocks* and *Nine Maine Sketches* are as free as any in the history of art. The sureness of Avery's hand is evident in the selection of Flobrush drawings reproduced in this book. *Many Colored Rocks* (plate 73), *Surf and Rocks* (plate 76), and *Nudes on the Rocks* (plate 75) are three loosely sketched Flobrush drawings done in Maine. Commenting on the freedom of Avery's drawing of the sea, Henry Geldzahler said, "The drawing may be somewhat eccentric, childlike or primitive, but it is exactly right in terms of Avery's personal vocabulary of form."[37]

Avery suffered his first major heart attack in January 1949. He was hospitalized for six weeks and later rested at a friend's home in Millbrook, New York, where he did *Victorian Interior* (plate 52) and *Girl Reading* (plate 53). Still in poor health, Milton spent the winter with Sally at an artists' center in Maitland, Florida. While recuperating there he did *Seven Sketches* (plate 69). In this piece he mixes, on a single page, pencil and Flobrush studies of landscapes, seascapes, fish, and a head of March.

That winter Boris Margo, an artist and friend, introduced Avery to the monotype. The technique was thought to be compatible with his need not to exert himself. Avery responded enthusiastically, producing two hundred or more monotypes in the next few years. He loved the medium and the spontaneity it allowed. The need to work rapidly presented no problem, and each piece had implications for future paintings. Later, in the 1950s, Avery would be sponging thinned-out paint directly on his canvas as he had done on the glass plate used in making monotypes. The process allowed Avery's colors to appear to float on the surface of his paintings in a manner related to that of Morris Louis and the Color Field painters.

After drawing his familiar subjects on a piece of glass with fluid paint, Avery printed his images on rice, watercolor, and toned papers. He did so much experimenting with everything from overprinting and overpainting to printing on wrinkled paper that it is often impossible to know exactly how each monoprint was created. What we can be sure of is that Avery, in a relatively short period of time, produced a body of work that placed him in the first rank of those employing unique print techniques. The Painterly Print an exhibition at the Metropolitan Museum of Art in 1980, featured seven of Avery's works, establishing him as one of the recognized masters of the monotype.

Milton Avery's congenial art should not distract us from the originality of his inventions. Some of the larger monotypes such as *Birds with Ruffled Sea* (plate 84) are as much painting as they are drawing. Freely worked and embellished with color saturations, works like this are a vital part of Avery's total production as an artist. Occasional smaller pieces such as *Grazing Animal* (plate 86) and *Grazing Animal—Gray* (plate 85) demonstrate the concentrated energy and gentle disposition of the artist at the height of his creative power. *Grazing Animal* and *Grazing Animal—Gray* are more than simply related images with color added to each subject; one is apparently the ghost print of the other. The improvisational character of these two monotypes reveals Avery's continuing inventiveness.

During this period Avery also explored a variety of other printmaking techniques. He had less interest in the technical aspects of the printmaking craft than in the expressive possibilities inherent in each medium. Avery had an instinct for the right materials to suit his visual needs. Using discarded copper and zinc plates given to him by his sister-in-law in the 1930s, he created *Young Girl Nude* (plate 104), *Sally with Beret* (plate 22), and twenty-eight other drypoint editions. Between 1952 and 1955 he made twenty-one very lively woodcut prints including *Fantail Pigeon* (plate 94). In both 1951 and 1952 Avery designed the lithograph that was published in the souvenir catalogue for the Artists Equity Ball. The first Artists Equity litho-

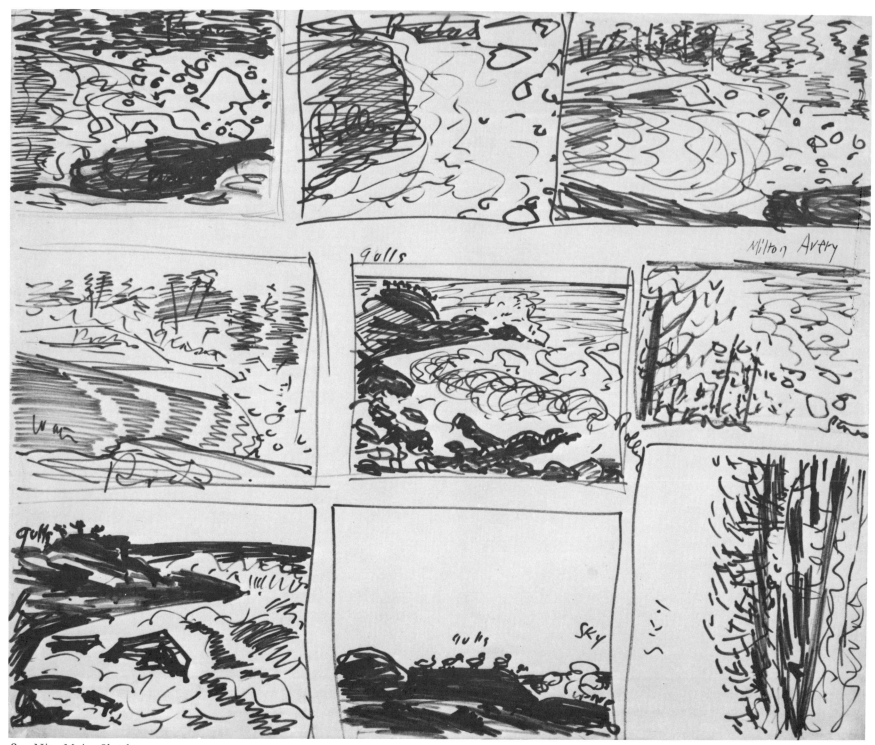

8. *Nine Maine Sketches*

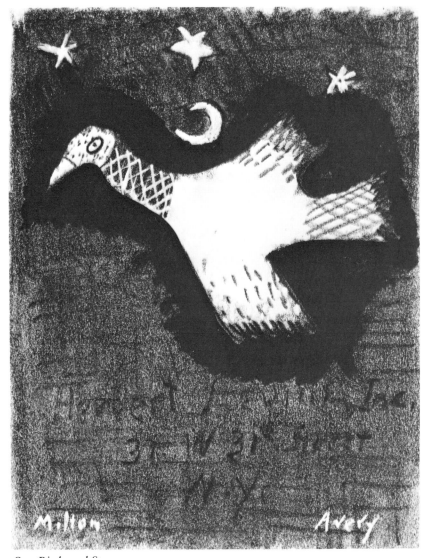

9. *Birds and Stars*

Avery's work gave no evidence of his continuing difficulties. In 1950, one year after his heart attack, Avery's relationship with Rosenberg ended, leaving him without a dealer. Later that year he agreed to exhibit about twenty of his monotypes at the Laurel Gallery in New York. Priced at one hundred dollars each, none sold. His brief critical acclaim of the 1940s was replaced by what Haskell called "critical eclipse"[38] and financial hard times. In spite of having more than his fair share of frustrations, Avery never faltered in his persistent struggle. He said in a written statement, "Keep painting—day in—day out. Be absorbed by it. Hold on to the dream—try to make the great dream a reality."[39] His drawings, watercolors, oils, and prints appeared more effortless than ever, disguising whatever artistic struggle existed.

In 1951 Grace Borgenicht asked him to join her new gallery, and she became the first dealer to sell his drawings as well as his paintings. The summers of 1950 and 1951 were spent in Woodstock, New York. In this idyllic setting, with Sally, March, and Picasso at his side, Milton began to regain his strength. A double pencil drawing *Summer Sketches* (plate 49) shows March reading on the porch at Woodstock. It became the basis for one of the artist's most successful figure paintings, *Summer Reader* (plate 48). A comparison of the drawing and the painting clearly shows Avery's reductive process at work. He searches out the most telling contours and pares away the rest. What is given up in the drawing can be measured by what is gained in the painting. With ever greater simplification, he approached abstraction. He knew its nature as he knew the nature of the subject, but for Avery abstraction and realism always remained equal cohabitants in friendly communion. In *Six Sketches* (plate 54) surfaces and their edges are what concern the artist, with the element of line his exacting instrument. His is not the sensual undulating line used by Degas or the fanciful line he admired in the works of Paul Klee. Rather it is forged to reconstruct the truth as he saw it, a buoyant line, like a chisel in the hands of a sculptor of two-dimensional shapes. His eye was trained to remove distracting incidents, define edges, and maintain the identity of the subject. Works like *Six Sketches* could not be more removed from the Cubist handling of form, yet Avery manages to present a convincing antisculptural space containing figures that are as solid as they are weightless.

graph, *Head of March* (plate 31), printed in an unsigned edition of two thousand, is derived from *March* (plate 32), a drawing of 1951. These two similar images show the bold directness of Avery's act of seeing. *Birds and Stars* (plate 9), another lithographic crayon drawing, was translated into the 1952 Artists Equity print. This delightfully quirky bird is pure Avery. Endowed with a unique personality, it flies with dignity through the evening sky, no doubt on its way to the Artists' Ball.

As we have seen, drawing the figure was an enduring, near obsessive activity throughout Milton Avery's life. The necessary limitations imposed by the reality of a model and his own need to bring about a new, more finely sharpened actuality brought him back again and again to the figure. Avery distorted his figure drawings sufficiently to appear inept to some critics. His models were mostly female, and they are as solidly assembled as the pictorial spaces in which they are enclosed. Drawings done in sketch class, like *Nude Kneeling* (plate 107) and *Big Woman* (plate 108), contain the monumental quality found in many of the landscapes and seascapes. The placement of the model along the top of the sheet *Reclining Nude* (plate 112), with a great open space separating her from the signature on the bottom, is anything but accidental. The paper is not just drawn upon, but becomes an arena where open spaces are as vital as closed shapes. In *Five Nudes* (plate 110) small featureless heads, large thighs, and elongated bodies are used to construct women who are as technically convincing as they are persuasively assembled. Even though the model is simplified and almost generalized, she maintains an insistent individuality. *Sturdy Nude* (plate 114), *Monumental Woman* (plate 115), and *Proud Nude* (plate 116) are composed of a few mobile lines and simple shapes woven into a tightly articulated overall design. Flat planes are locked together, each parallel to the picture surface. Avery's vigorously drawn contour line defines the unique wholeness of each figure while it captures the gesture and rhythm of each pose.

In 1952 Avery took his only trip to Europe. He, Sally, and March visited London, Paris, and the French Riviera for three weeks during the summer. Too weak to visit museums, he nevertheless managed to fill a 2- by 4-inch sketchpad with his usual compacted miniature drawings. In 1953, 1954, and 1956 Milton and Sally were both awarded fellowships and studio space at the MacDowell Artists' Colony in Peterborough, New Hampshire. *Open Door* (plate 77) is a small drawing of the door to Milton's studio there. It is as direct and unpretentious as *Towering Trees* (plate 78), an austere crayon study that relates to other works of that period. During Milton and Sally's second summer at the MacDowell Colony in 1954, March graduated from college and married Philip Cavanaugh. The following year Milton was seventy years old, and he and Sally spent one summer at the Yaddo Art

Milton, March, and Picasso at Woodstock, New York. Photograph by Sally Avery.

Colony near Saratoga Springs, New York. In 1957, 1958, 1959, and 1960 Avery produced a superb group of paintings based on summer impressions and summer drawings of Provincetown, Massachusetts. Once again drawn to an artists' colony, Avery sketched the dunes, the dock area, and the people who filled his life. He was less interested now in the unique character of his subject than in its universal nature. He further reduced the number of elements in each work, as in the double sketch *Inlets* (plate 63), which he did in 1957. All there is in

each half of this drawing is sky, land, and water. He sacrifices everything but clarity. One year later in a crayon drawing, *Green Sea Gray Sky* (plate 79), we see a considerably more minimalized rendition of sky, land, and water. This is as abstract as Avery would become.

Plagued by failing health, Milton Avery was unable to attend the February opening of his 1960 retrospective at the Whitney Museum. After his second heart attack in October 1960, he returned to New York from Provincetown in an ambulance. During the next four years he found it difficult to leave his Central Park West apartment and required oxygen to live from one day to the next. Finding it less of a strain, Avery chose to work for a time with a flat black oil paint on paper. Like the monotypes, these oils on paper were a cross between drawing and painting. *Mountain Landscape* (plate 61) was done at Lake Hill, New York, where Milton and Sally spent their last summers together outside New York City in 1962 and 1963. *Recumbent Nude* (plate 105) is a small drawing of 1956 that served as the model for *Nude Reclining* (plate 106), an oil on paper of 1962. Avery remains a consummate draftsman, accurately enlarging and maintaining the

feeling of the earlier sketch. The dots of the smaller piece become bold gestural lines in the oil as he gives his revived subject new substance and weight. He often did one or more drawings, watercolors, and oils of a subject, without regard for any hierarchy of mediums. The classification of a piece was of less concern than its artistic rightness.

New Friends on Old Sofa (plate 60) is an ink drawing that invites comparison with its larger mate, *Lavender Settee* (plate 59), an oil painting. Both pieces are equally successful. In these late works Avery continues to deal with flat surface and taut composition. In *New Friends on Old Sofa* he is the impeccable shape-maker whose crisp lines unravel like thread, while in *Lavender Settee* he is the precise colorist who creates snugly fitting shapes confined by soft edges. Anything unnecessary is removed, leaving the couch with its pattern in the drawing and its color in the painting to tie the figures together.

For Milton Avery, each drawing, like every painting, was meant to be a fully developed, complete statement. It did not matter what materials he used or what size the paper was, nor was it important how quickly he worked. The only question was, did the drawing work?

10. *Resting*

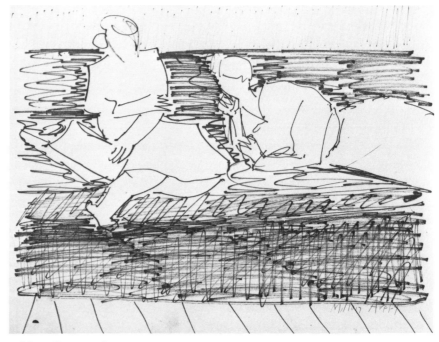

11. *Conversation*

Examples like *Hatted Woman* (plate 26) or *Belle Gross* (plate 28) are realized works of art rather than rehearsals for more formal pieces. The same is true of the many rapidly executed, informal drawings like *Conversation* (plate 11) of 1963. As varied as his drawings were in subject and style, each bears his authoritative imprint. When a drawing like *Conversation* was totally successful, a painting would inevitably follow.

Two Figures by the Sea[40] is a large canvas based on the drawing, *Conversation*. It was one of Avery's last paintings. In March 1964, he was placed in intensive care at Montefiore Hospital and remained at the hospital until his death on January 3, 1965. Avery was buried at the Artists' Cemetery in Woodstock. At his funeral, Rothko concluded his Memorial Address by saying, "I grieve for the loss of this great man. I rejoice for what he has left us."

Milton Avery was a man who never proclaimed himself independent of nature but joyously submitted to its wonders. His drawings are a legacy with rewards as rich and subtle as those found in his paintings. Future study of his graphic work will find inspired distortion, daring, gentle humor, and more. It will also reveal the unique handwriting of a modern master for whom drawing was an integral part of the process in every medium in which he worked. Every drawing reveals an intimate moment of discovery made visible. Every work reflects his half-smiling sense of an ordered universe. The joy, the preserved innocence, and the unassailable dignity we experience in Milton Avery's art all flow from his singular vision.

Burt Chernow

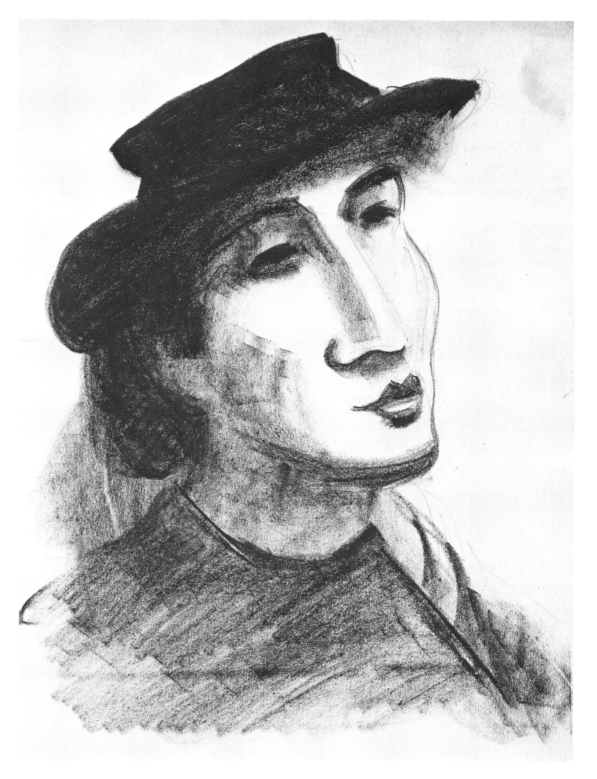

12. *Lily*

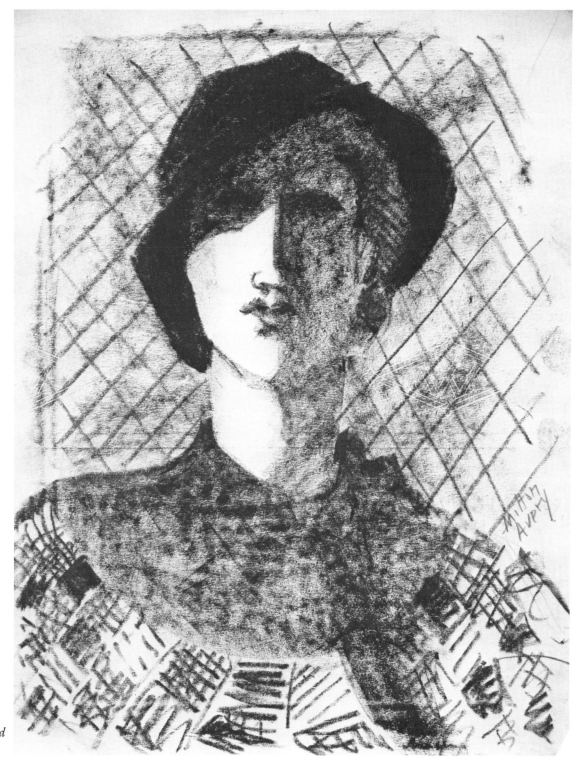

13. *Sally's Friend*

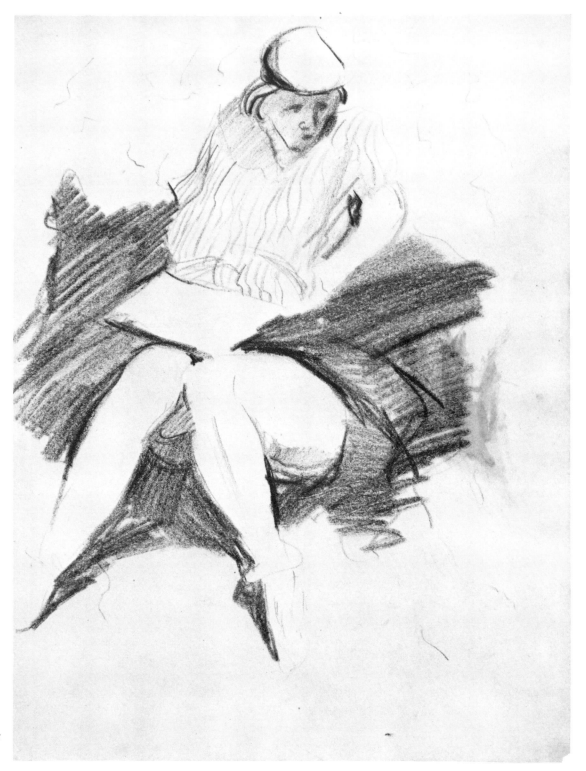

14. *Female Artist*

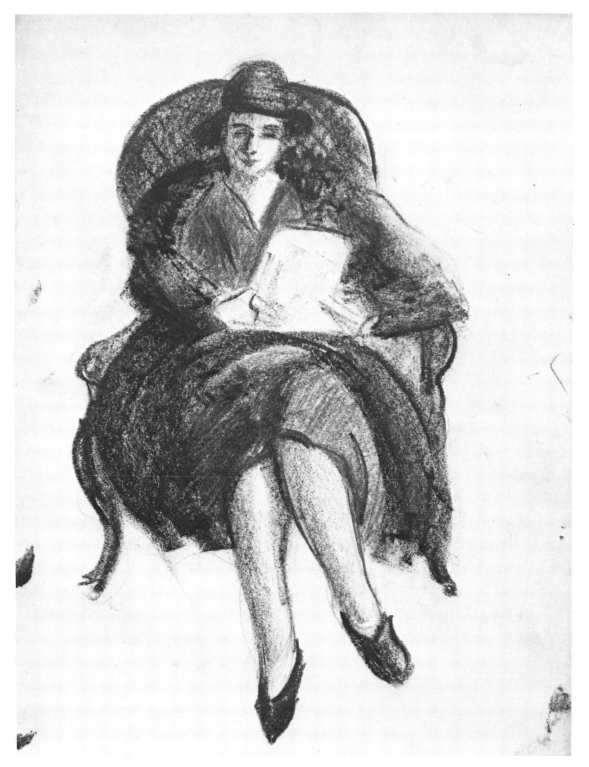

15. *Visitor*

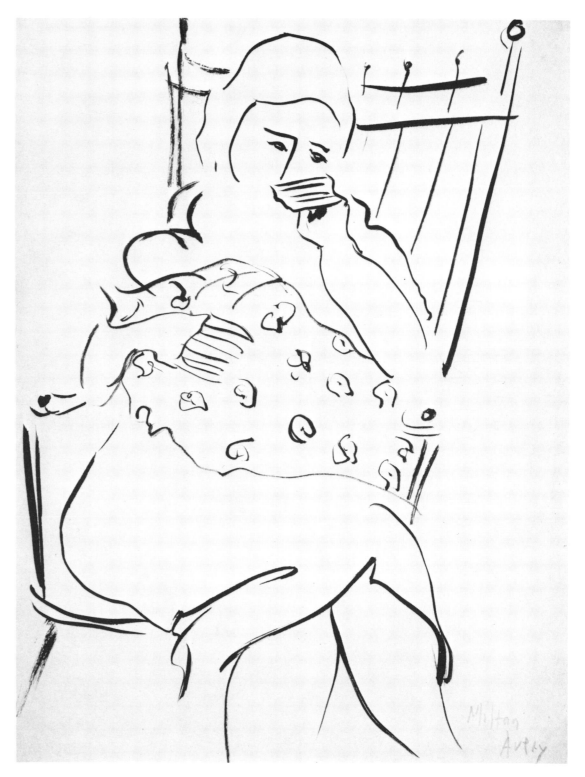

16. *Lullabye*

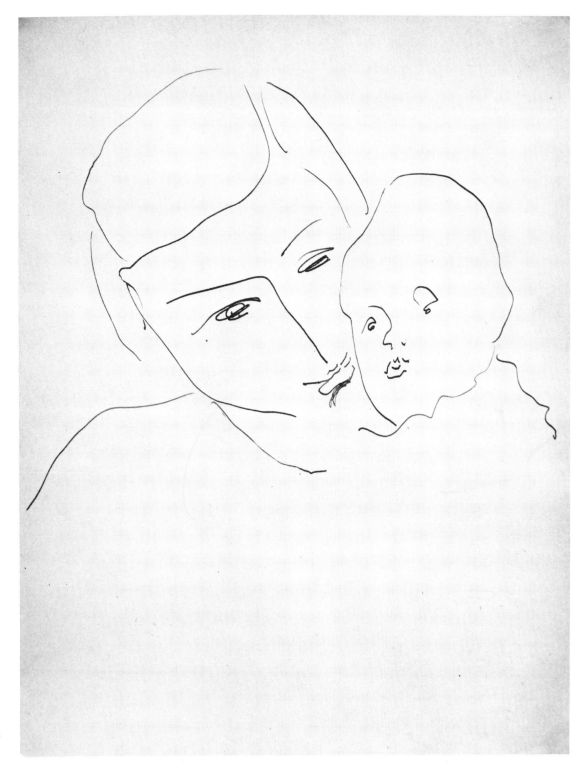

17. *First Born*

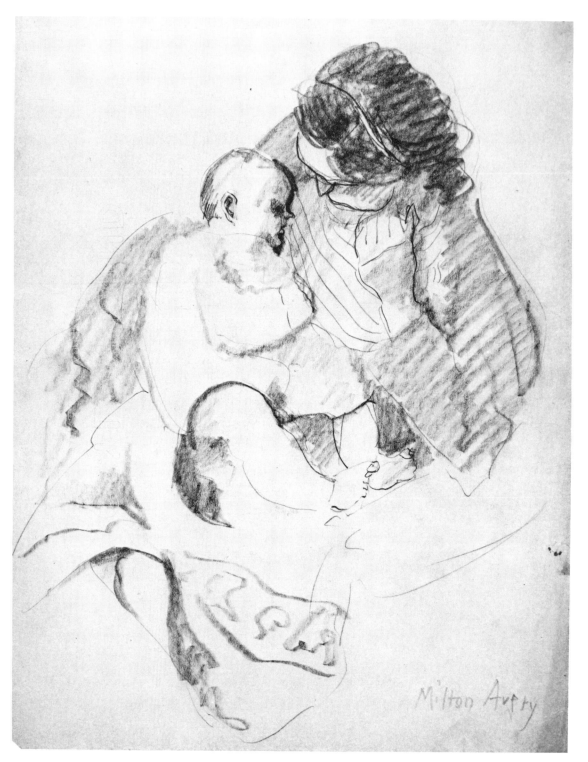

18. *Maternity*

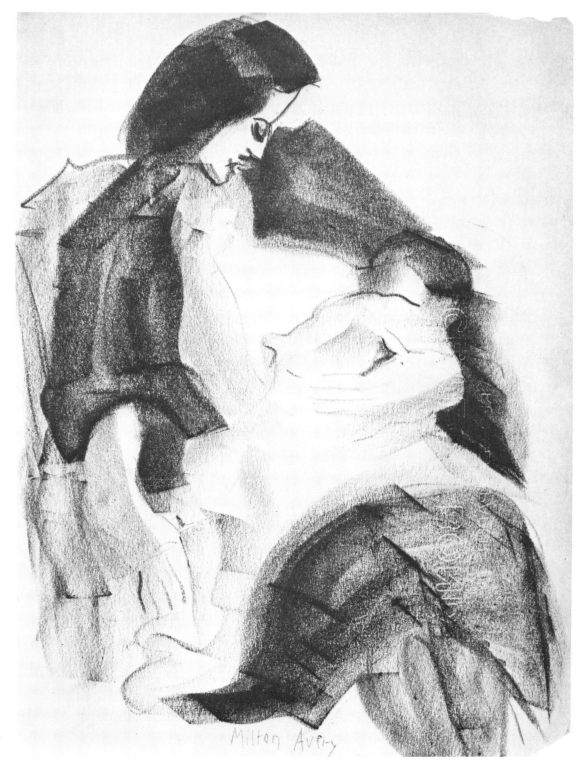

19. *Doting Mother*

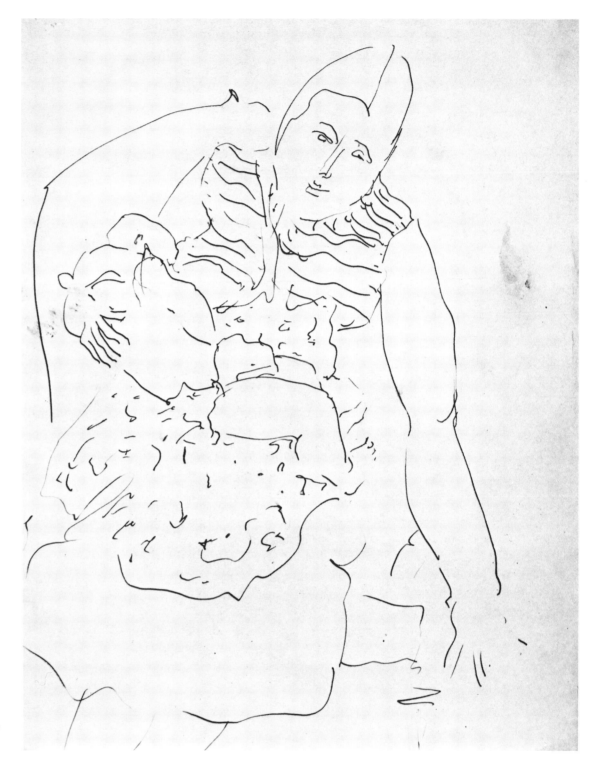

20. *Nursing Baby*

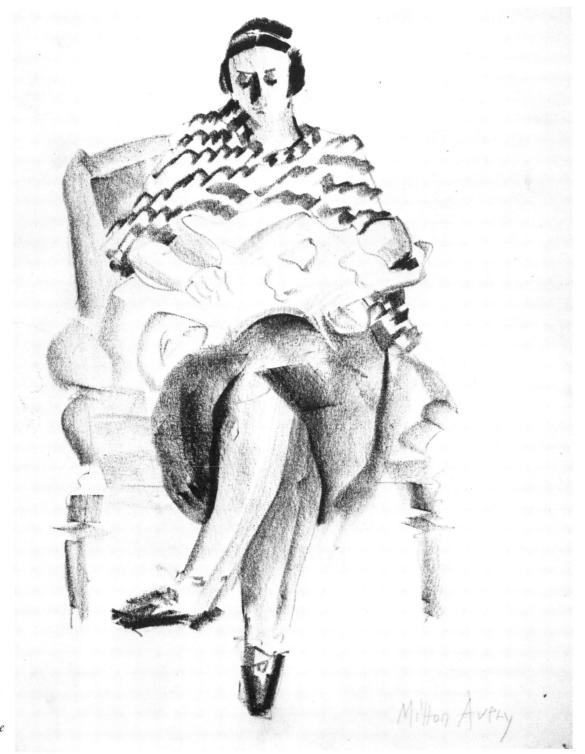

21. *Striped Blouse*

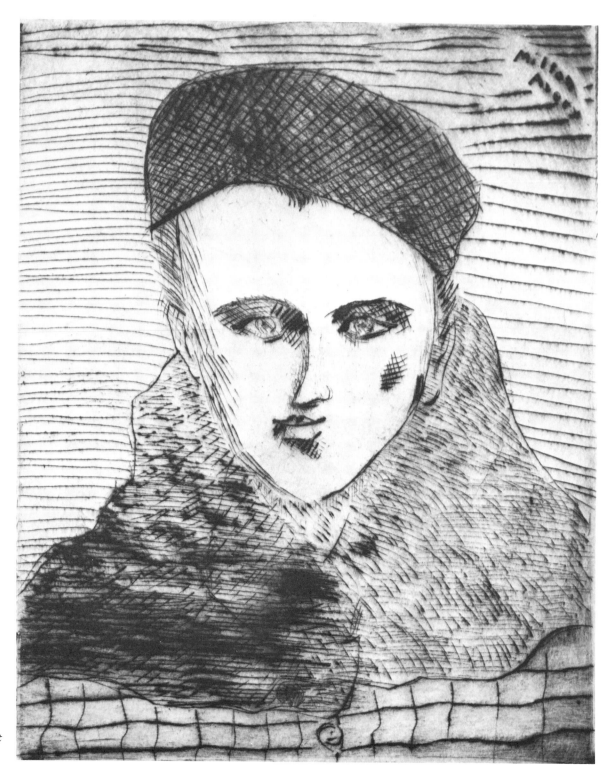

22. *Sally with Beret*

23. *Artist's Daughter*

24. *Gallery Woman*

25. *Belle Gross*

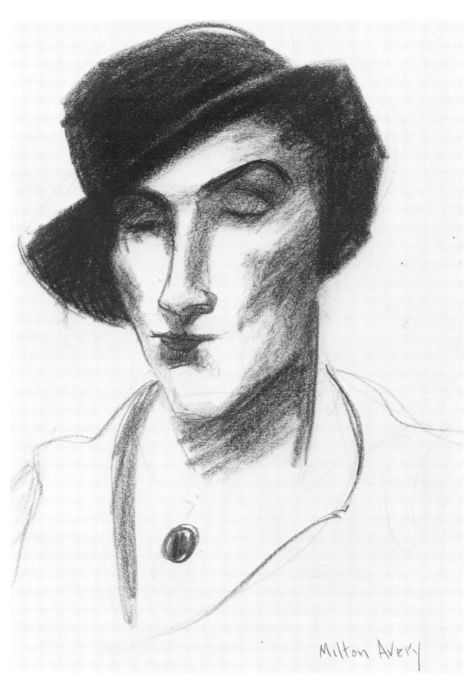

Milton Avery

26. *Hatted Woman*

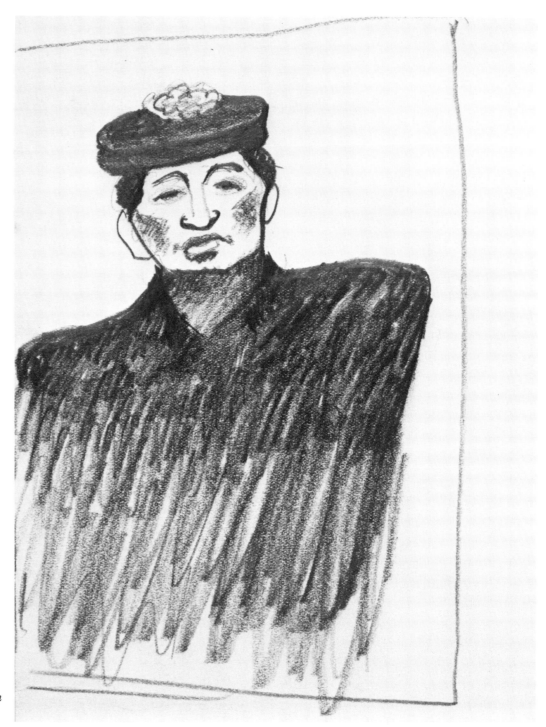

27. *Hatted Woman*

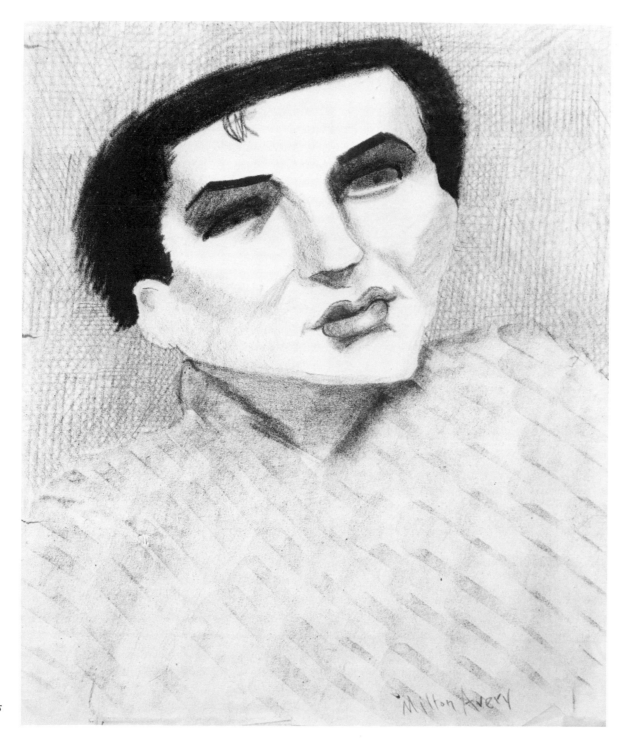

28. *Belle Gross*

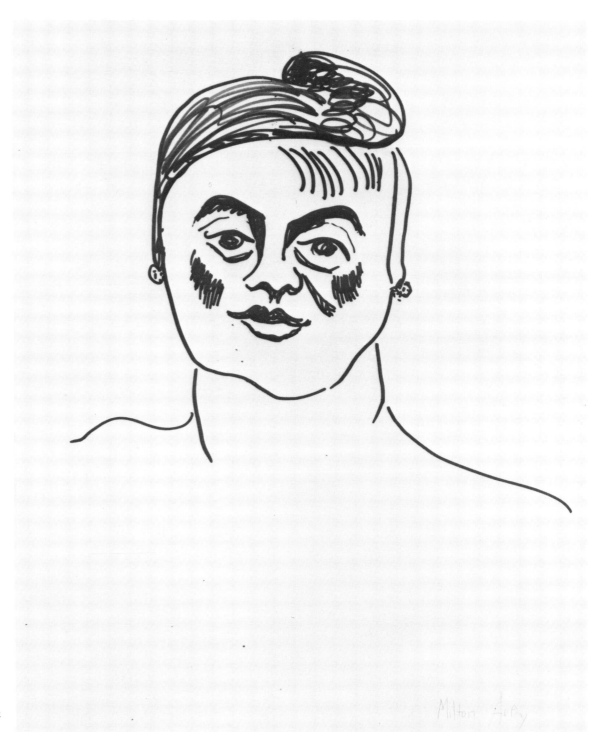

29. *Dolia*

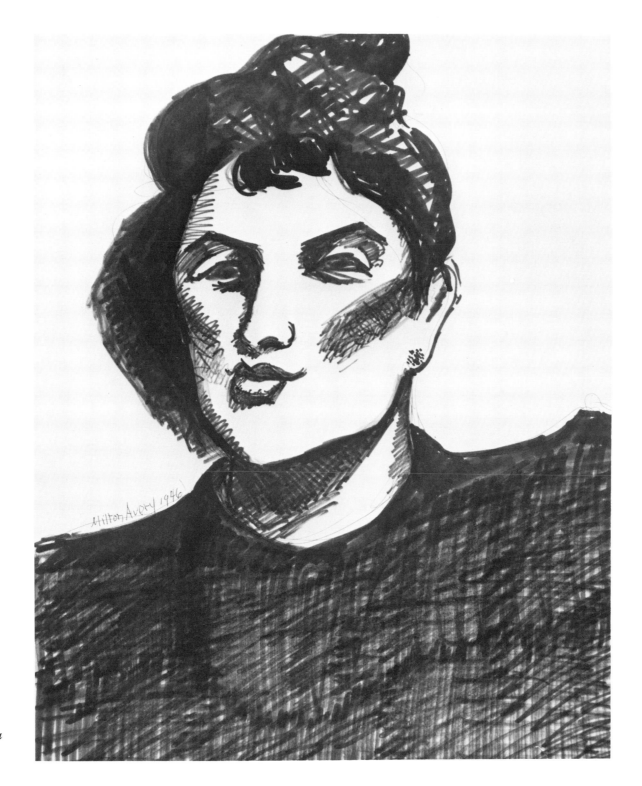

30. *Dolia*

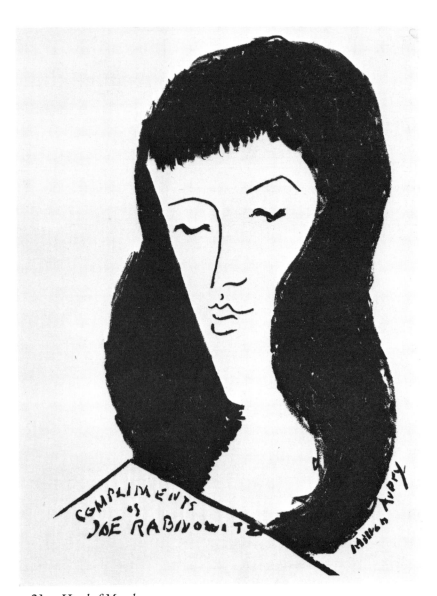

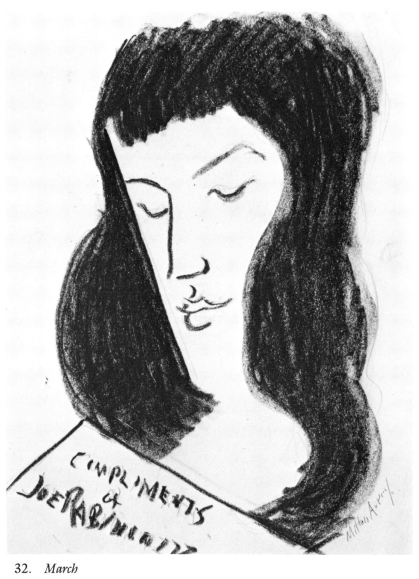

31. *Head of March*

32. *March*

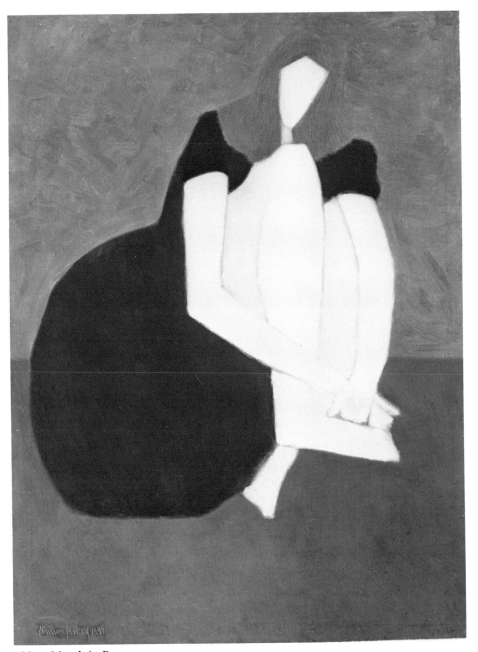

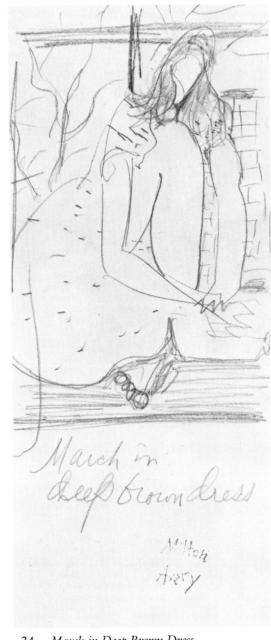

33. *March in Brown*

34. *March in Deep Brown Dress*

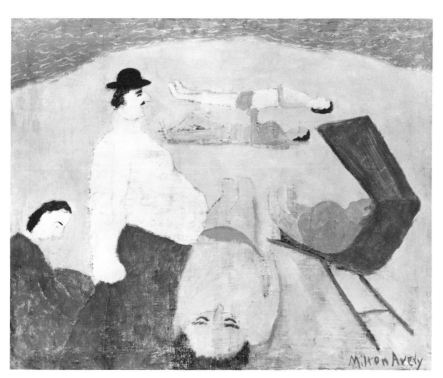

35. *Coney Island*

36. *Coney Island Sketches*

37. *Four Beach Studies*

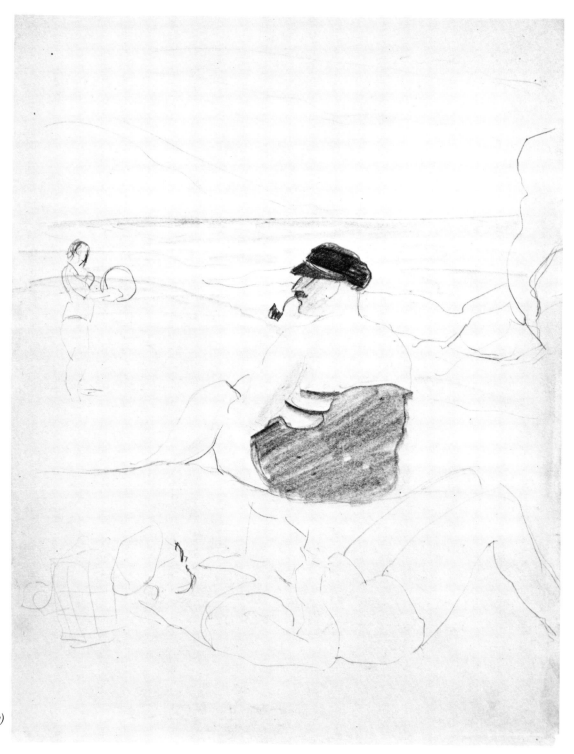

38. *Man with Pipe (Adolph Gottlieb)*

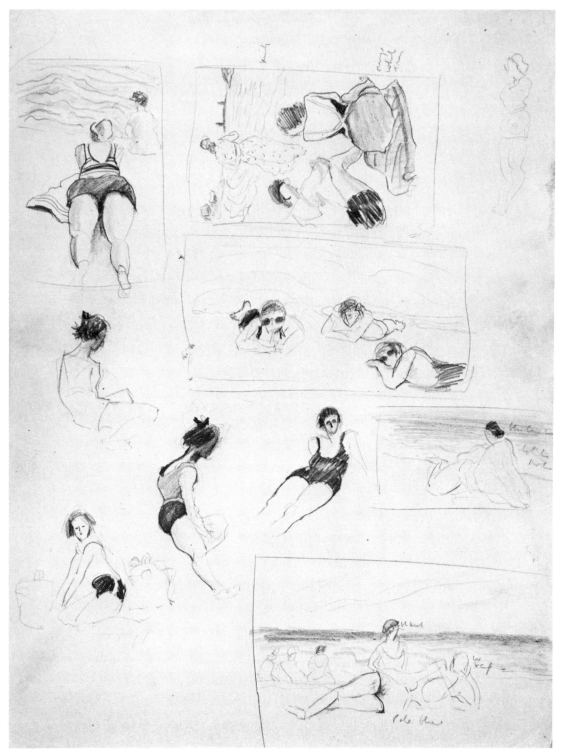

39. *Beach Studies*

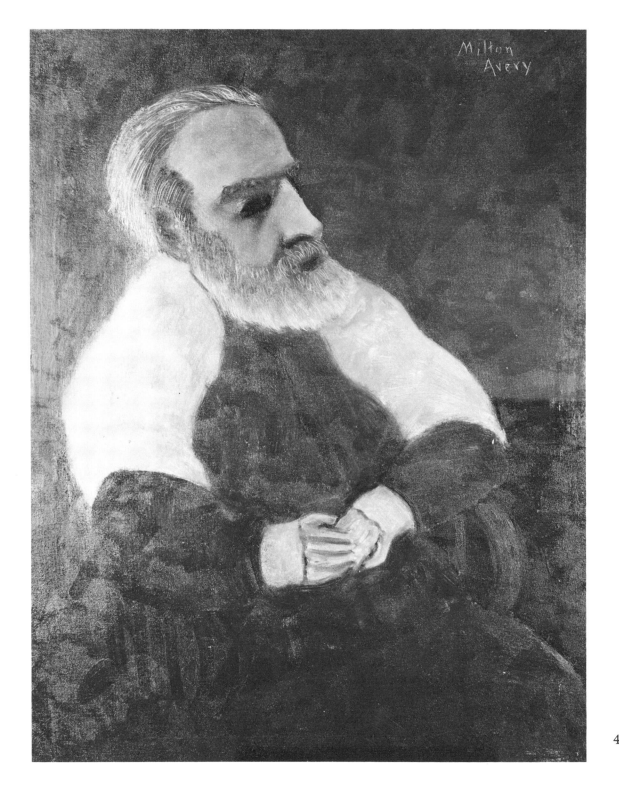

40. *Eilshemius*

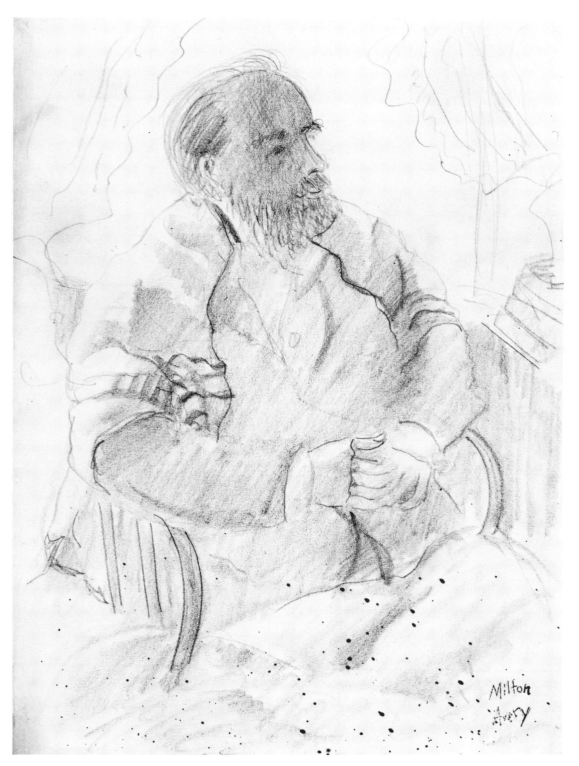

41. *Eilshemius*

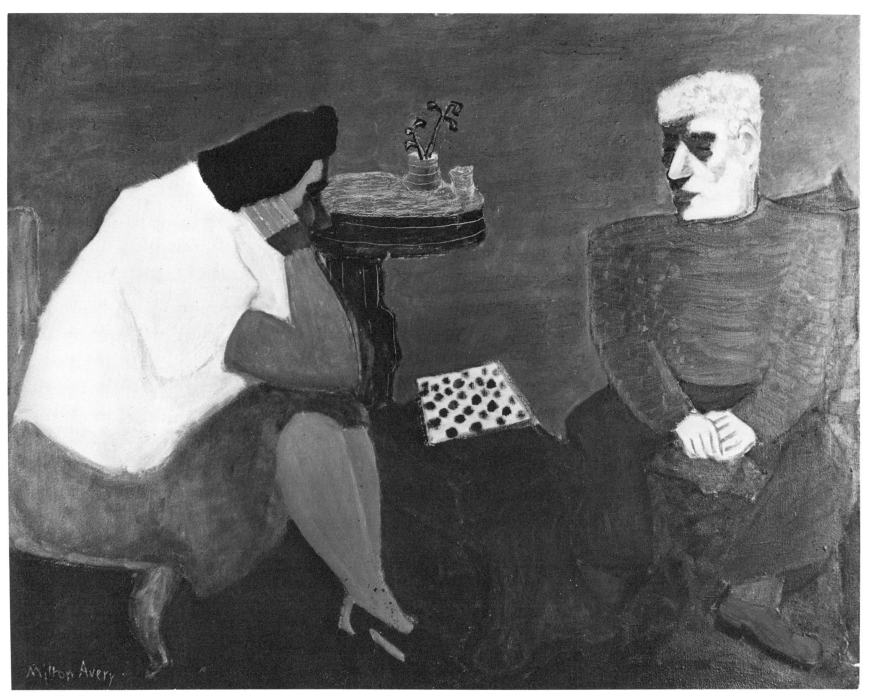

42. *Checker Players*

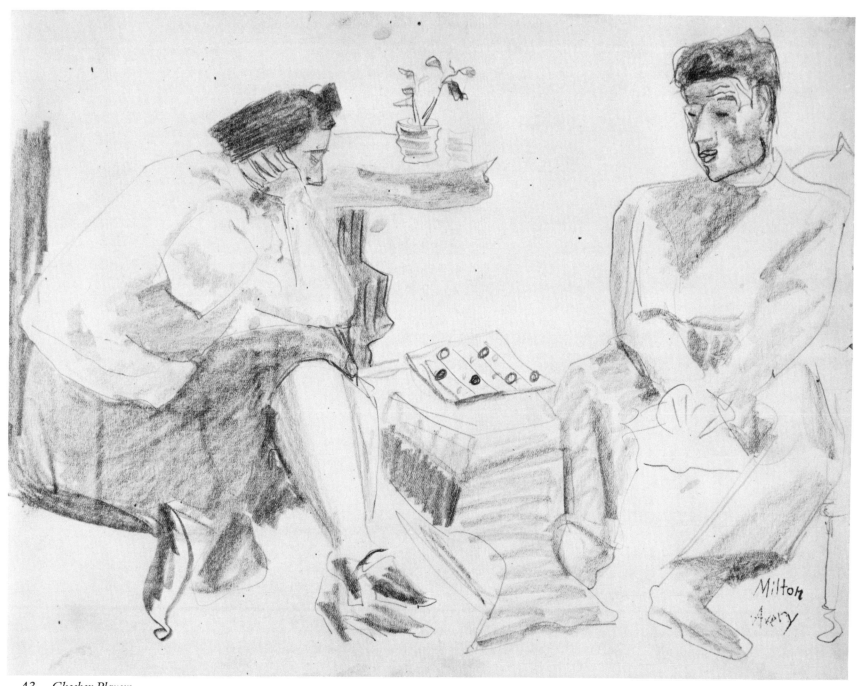

43. *Checker Players*

44. *Visitor*

45. *Woman with Folded Arms*

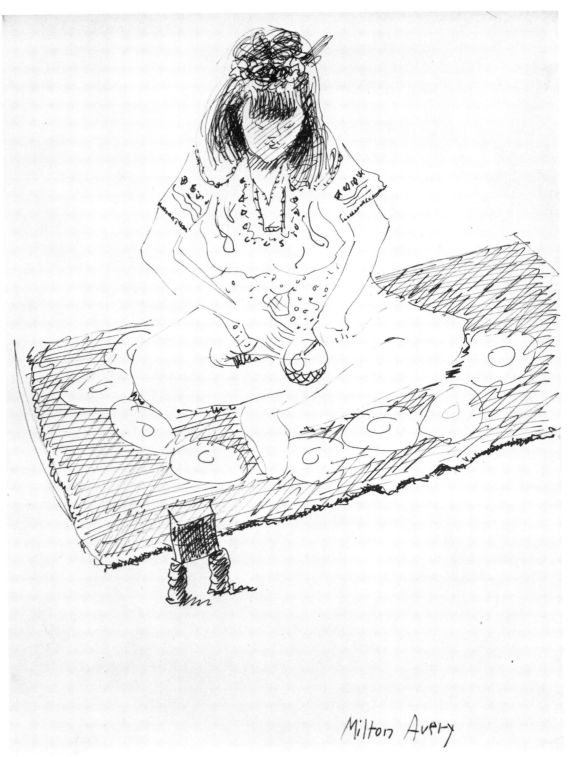

46. *Little Worker*

Milton Avery

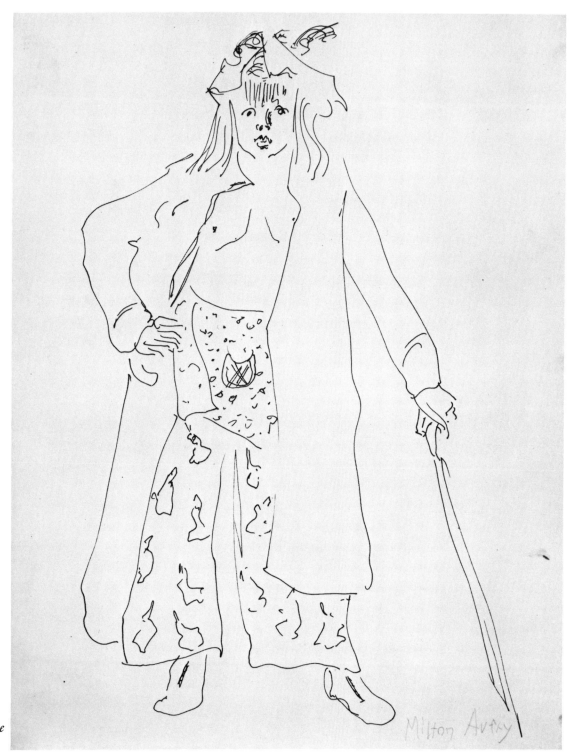

47. *March in Costume*

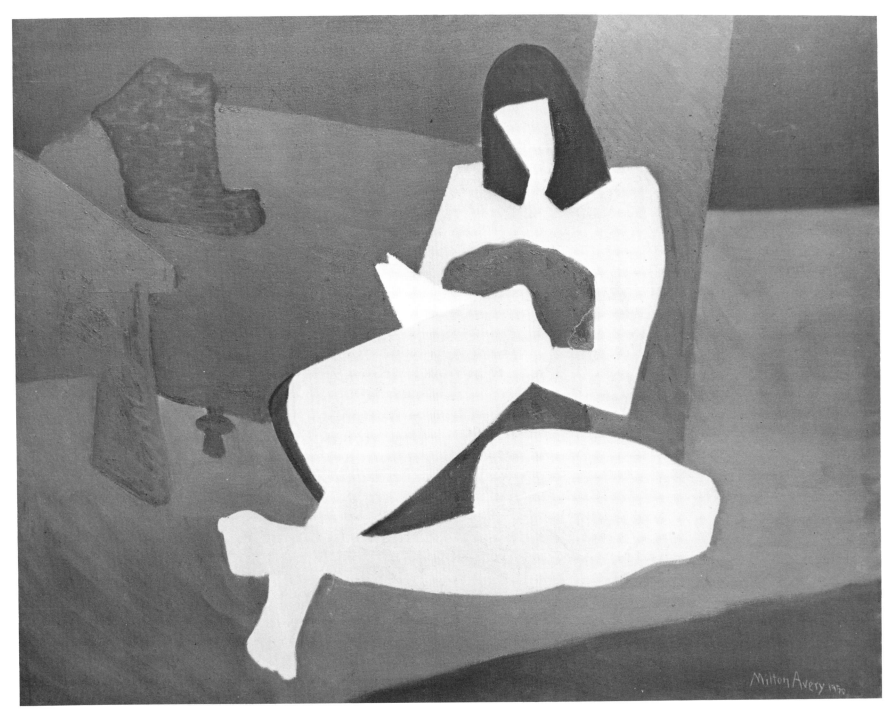

48. *Summer Reader*

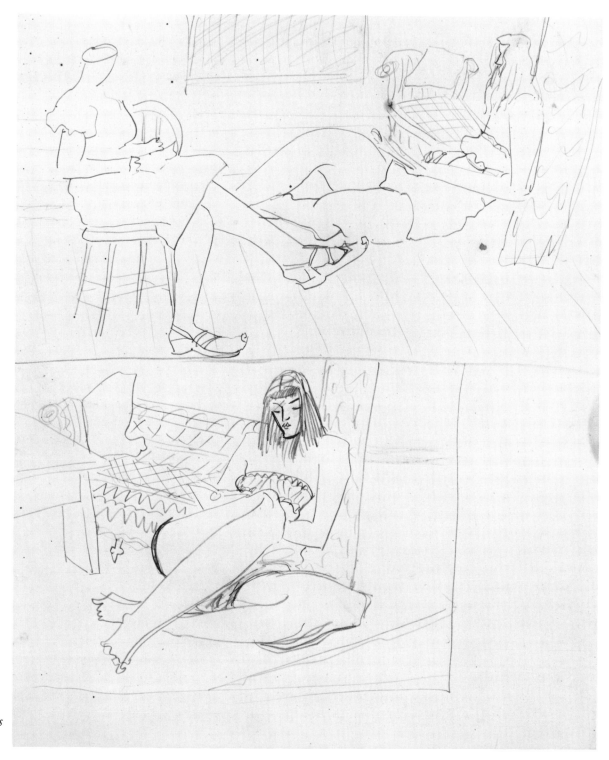

49. *Summer Sketches*

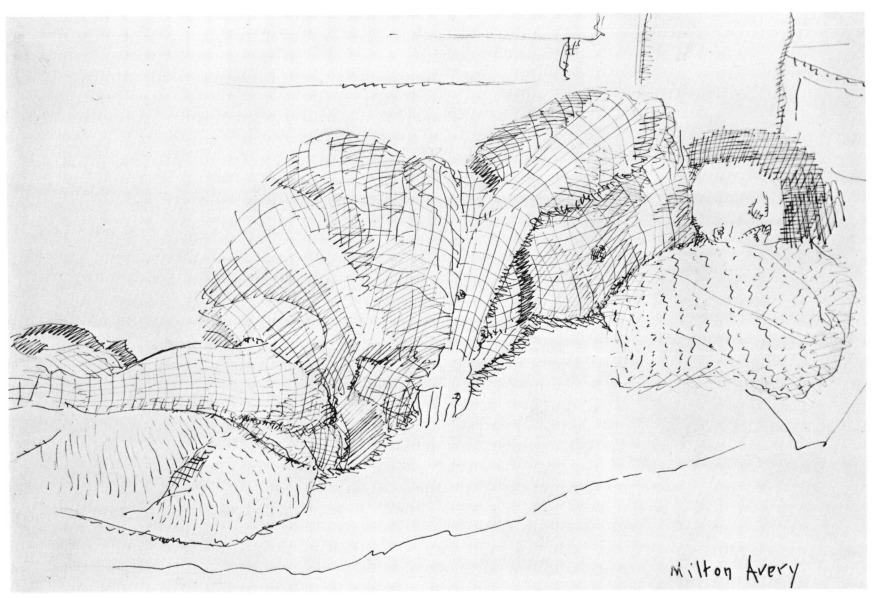

Milton Avery

50. *Sleeping Girl*

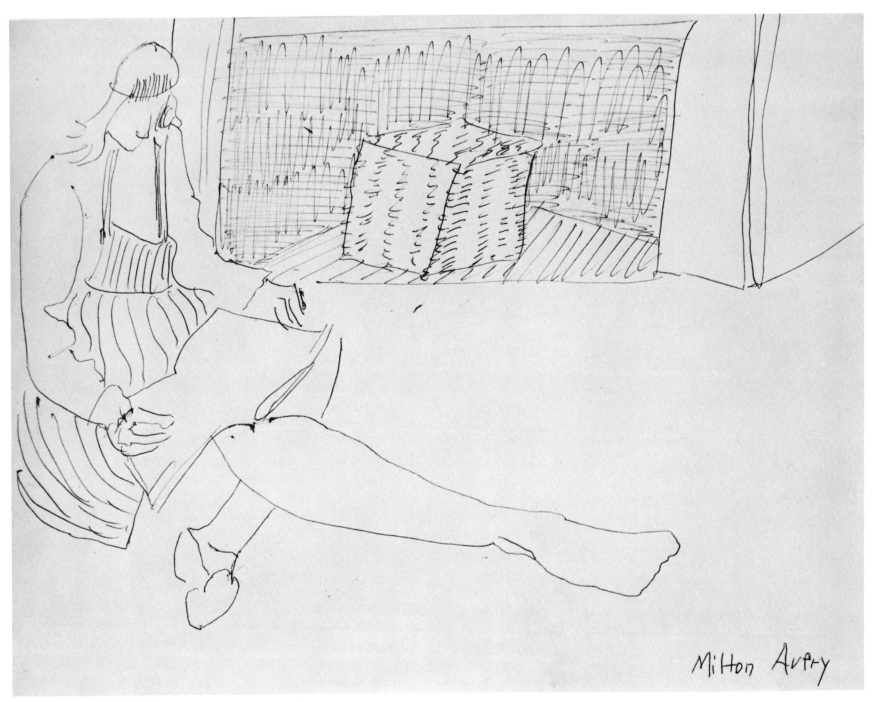

51. *March Reading*

52. *Victorian Interior*

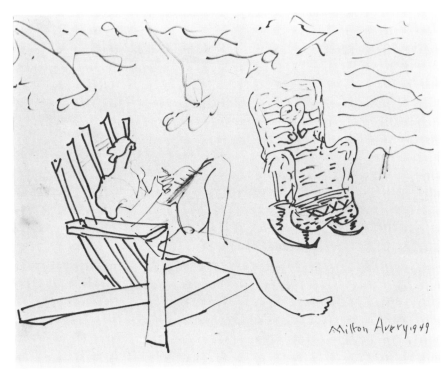

53. *Girl Reading*

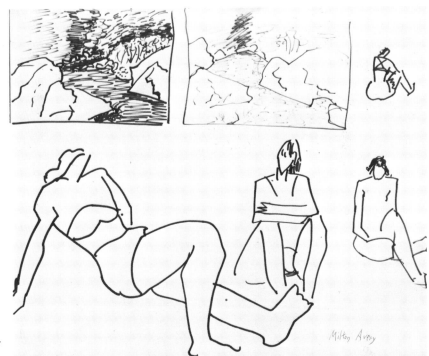

54. *Six Sketches*

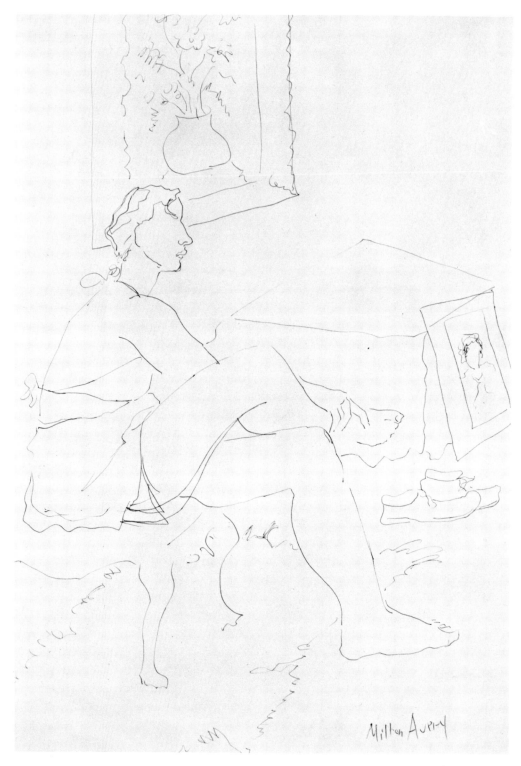

55. *Bather Indoors*

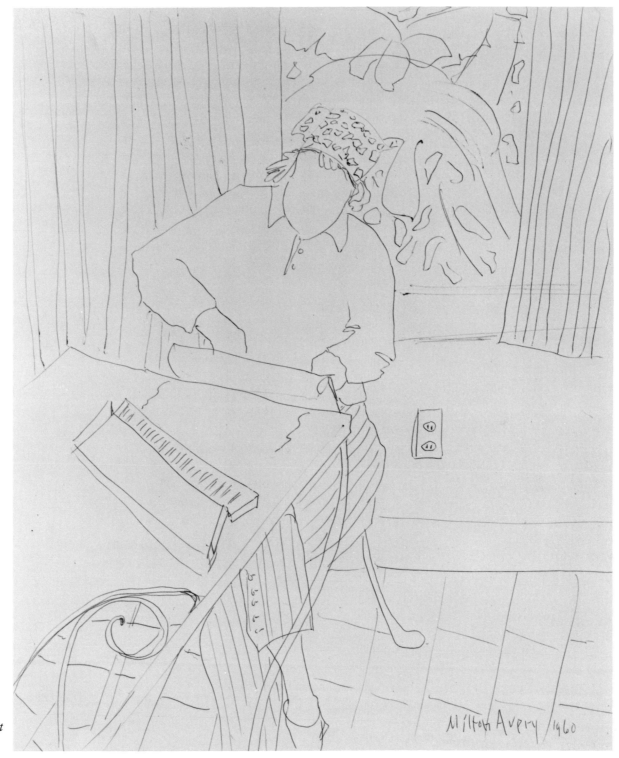

56. *Female Artist*

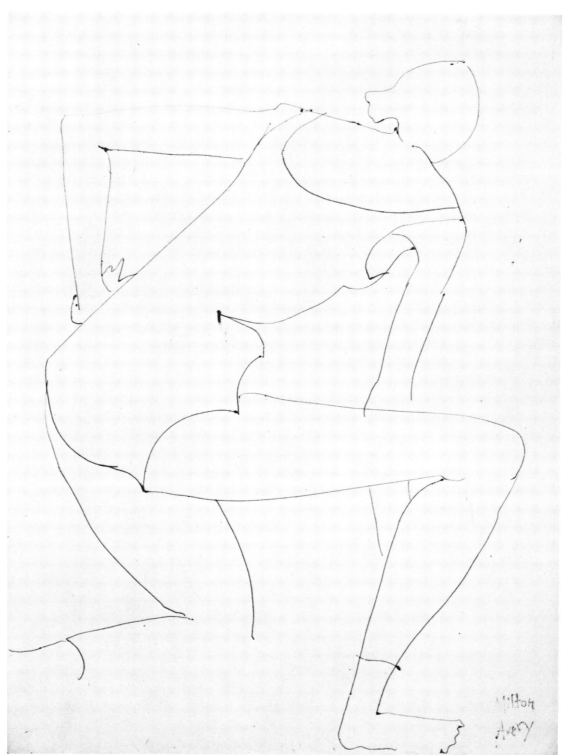

57. *Kneeling*

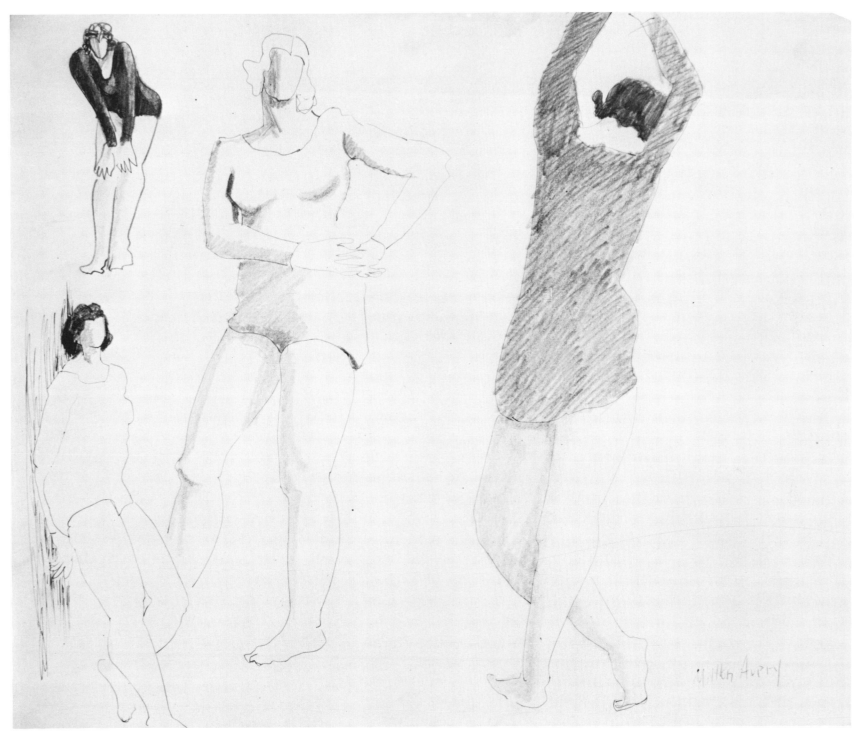

58. *Dancer*

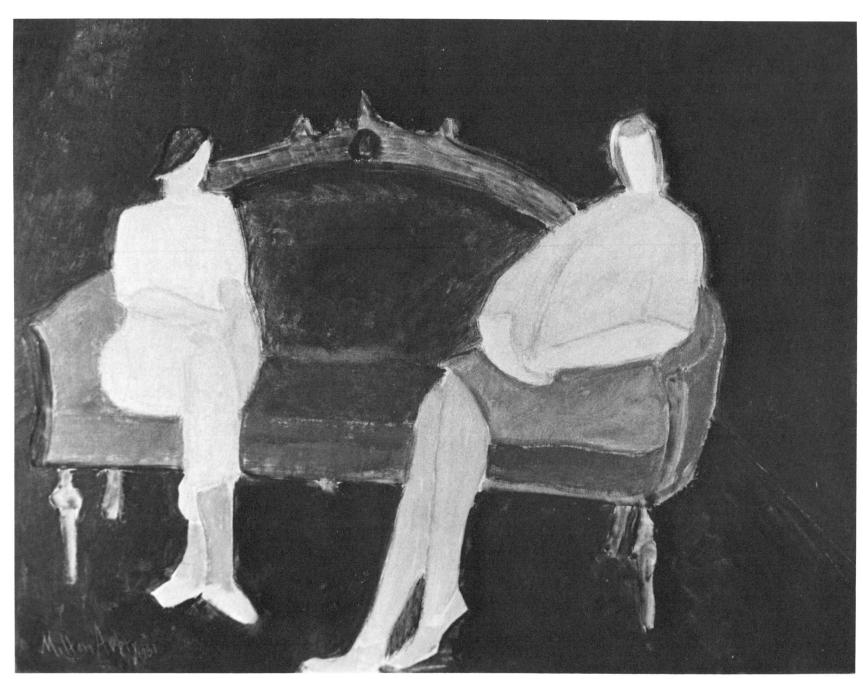

59. *Lavender Settee*

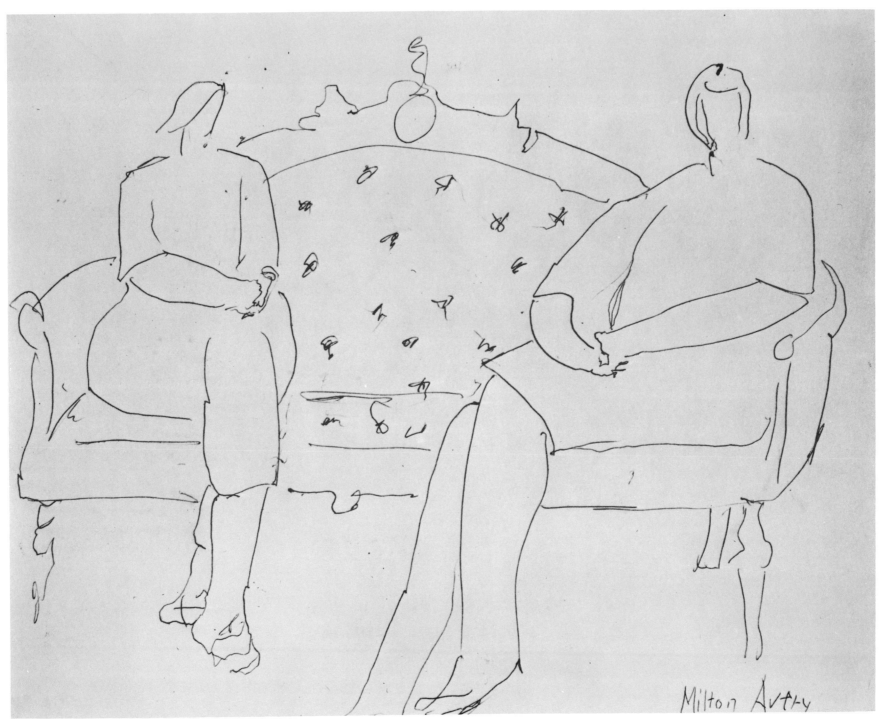

60. *New Friends on Old Sofa*

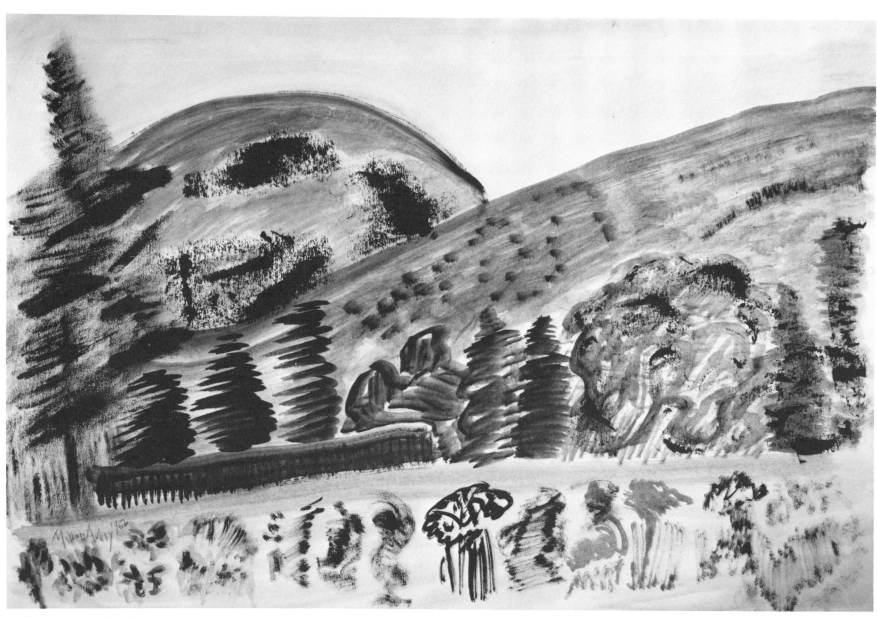

61. *Mountain Landscape*

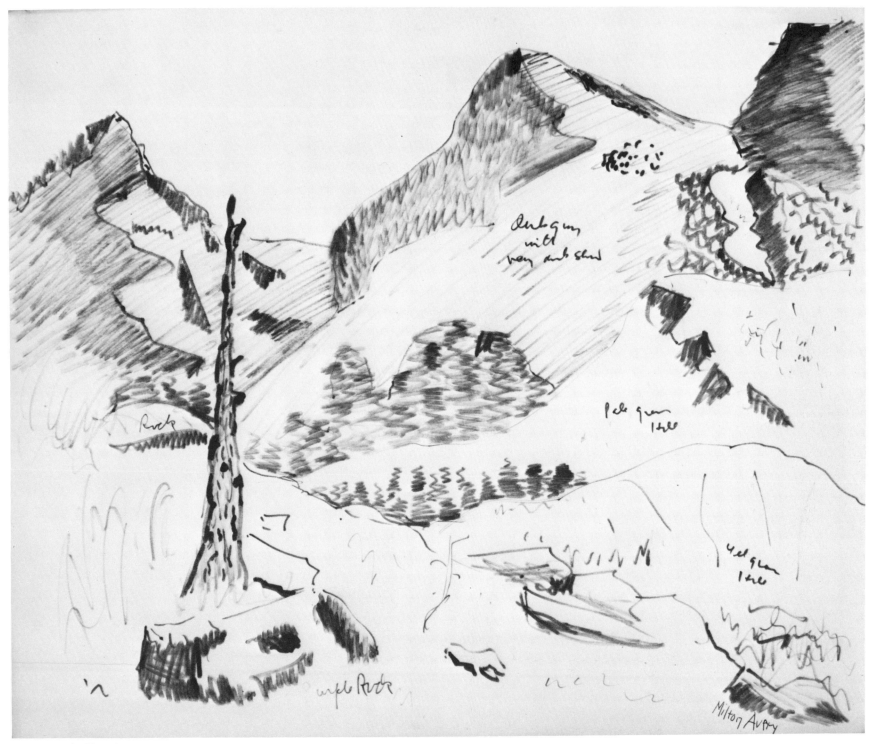

62. *Rocky Terrain*

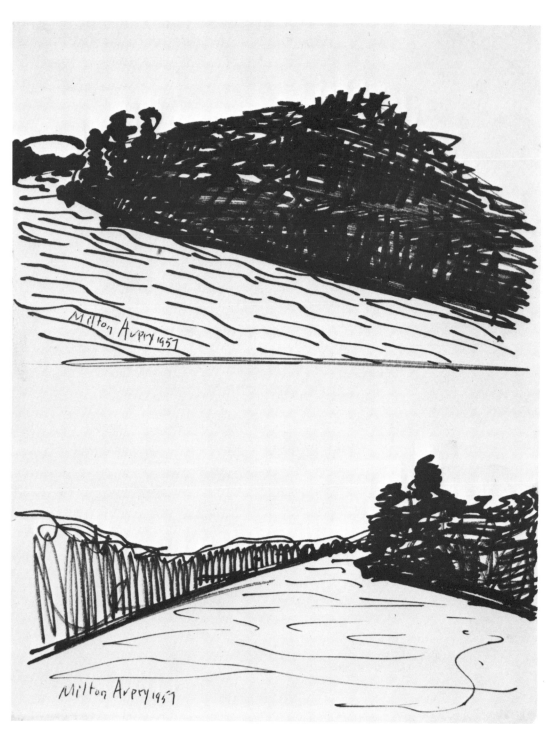

63. *Inlets*

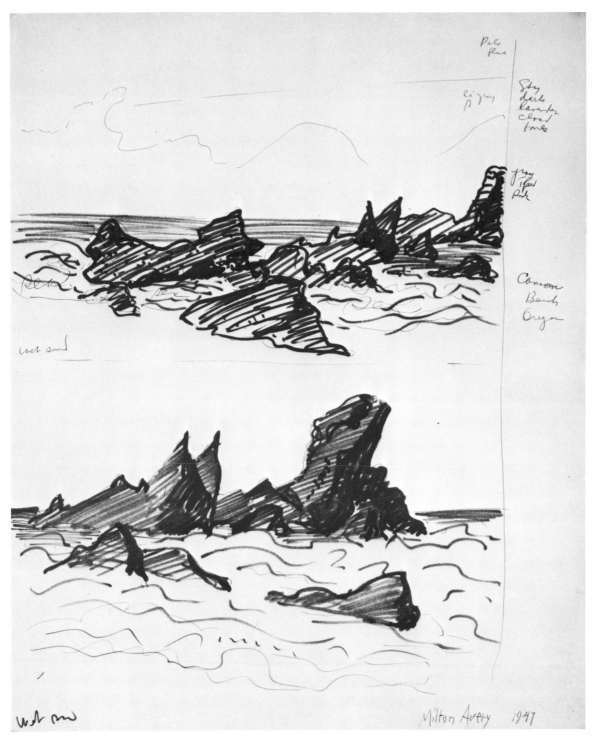

Milton Avery 1947

64. *Jagged Rocks*

65. *Pines by Sea*

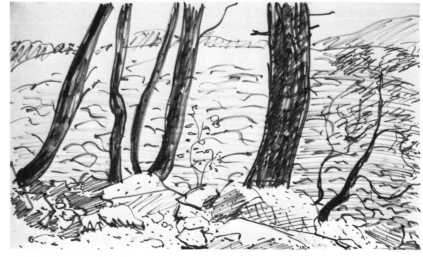

66. *Tree and Rocks*

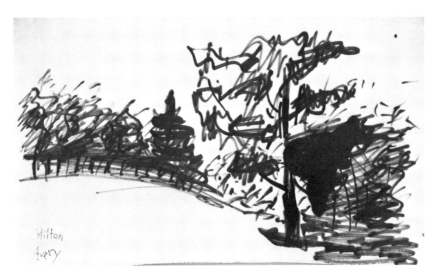

67. *Trail and Trees*

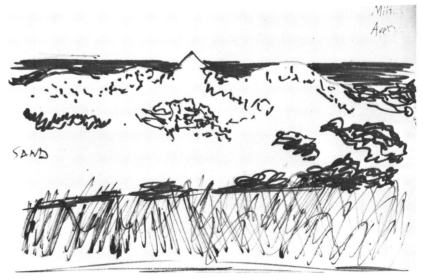

68. *Dunes and Sea*

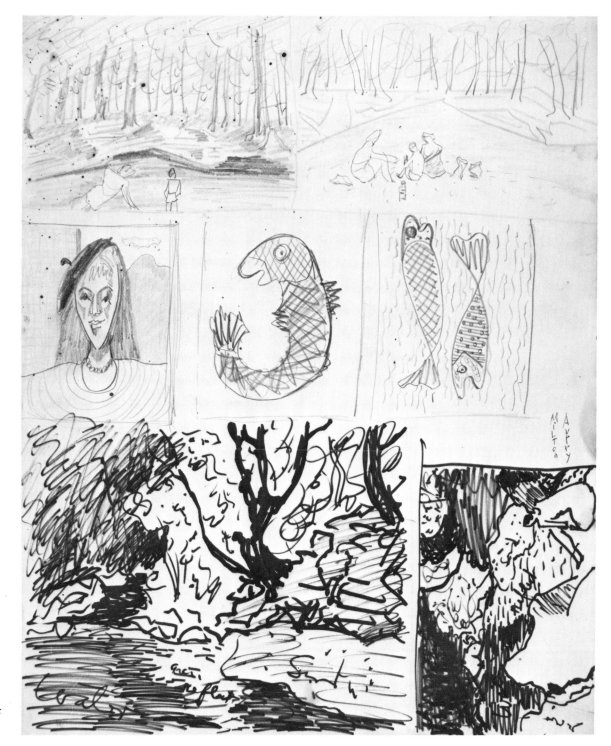

69. *Seven Sketches*

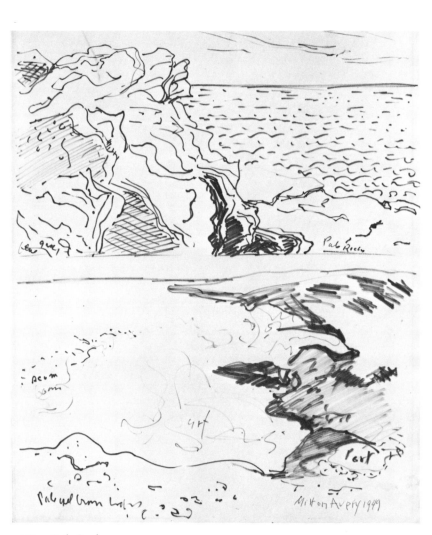

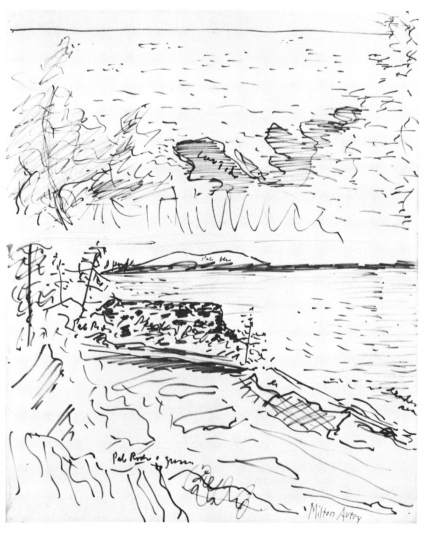

70. *Pale Rocks*

71. *Two Landscapes*

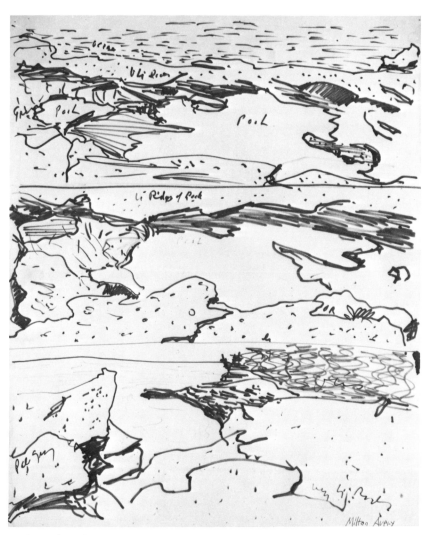

72. *Three Seascapes*

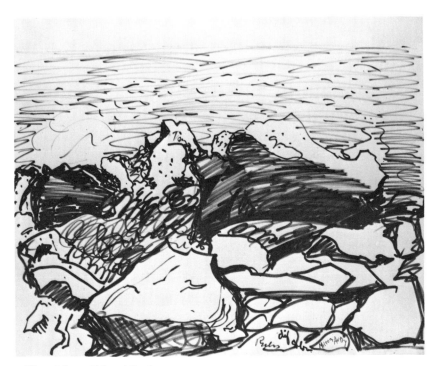

73. *Many Colored Rocks*

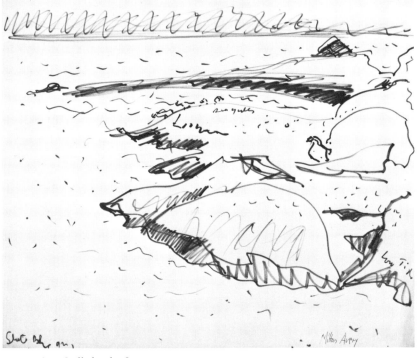

74. *Sea Gulls by the Sea*

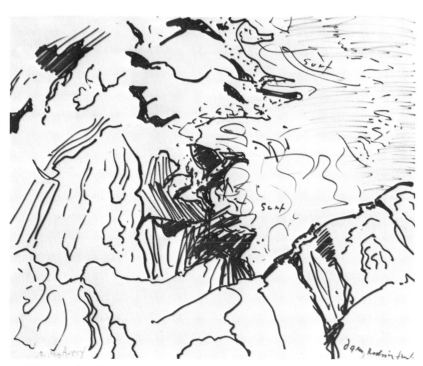

76. *Surf and Rocks*

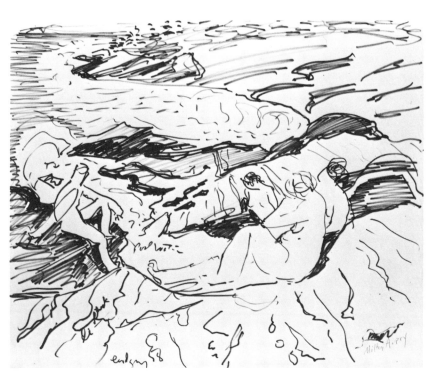

75. *Nudes on the Rocks*

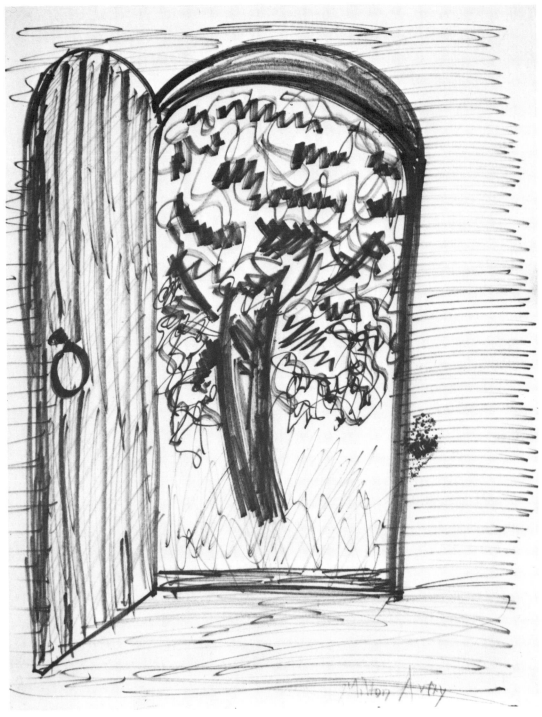

77. *Open Door*

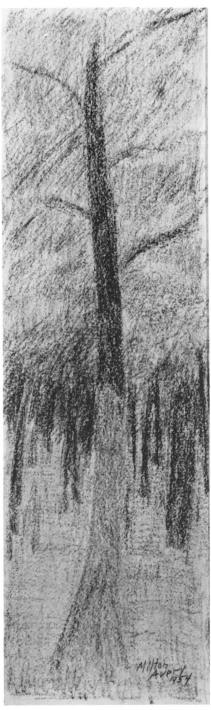

78. *Towering Trees*

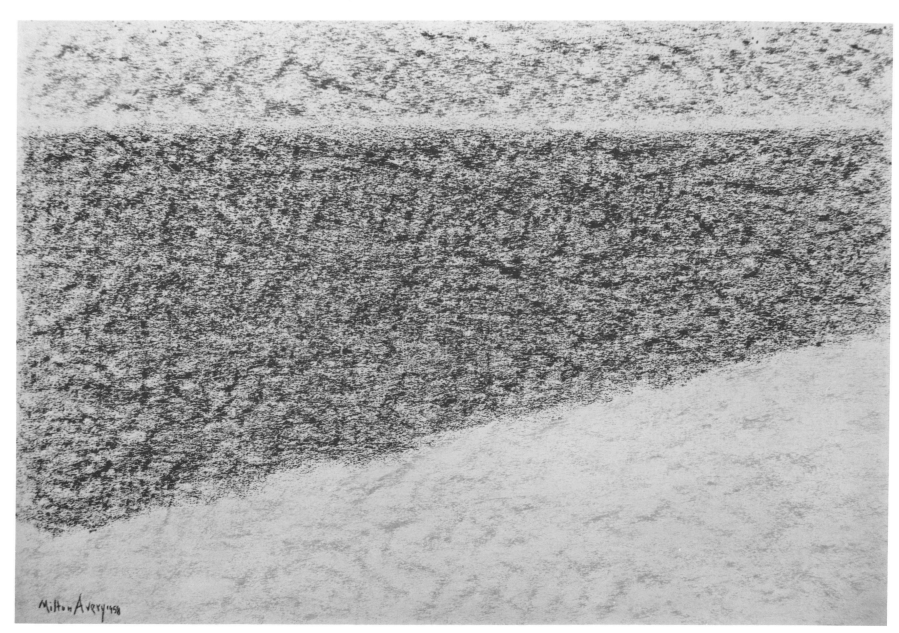

79. *Green Sea Gray Sky*

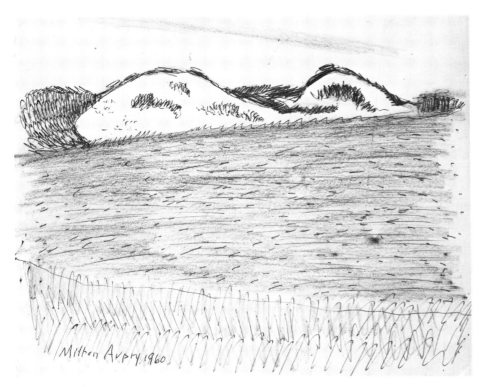

80. *Tender Dunes*

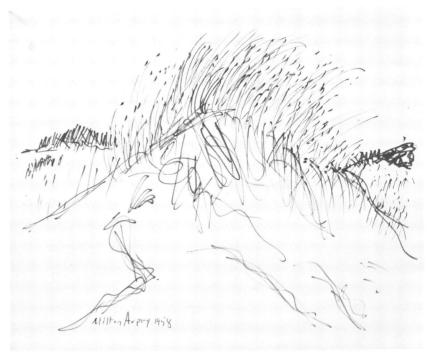

81. *Dune Grasses*

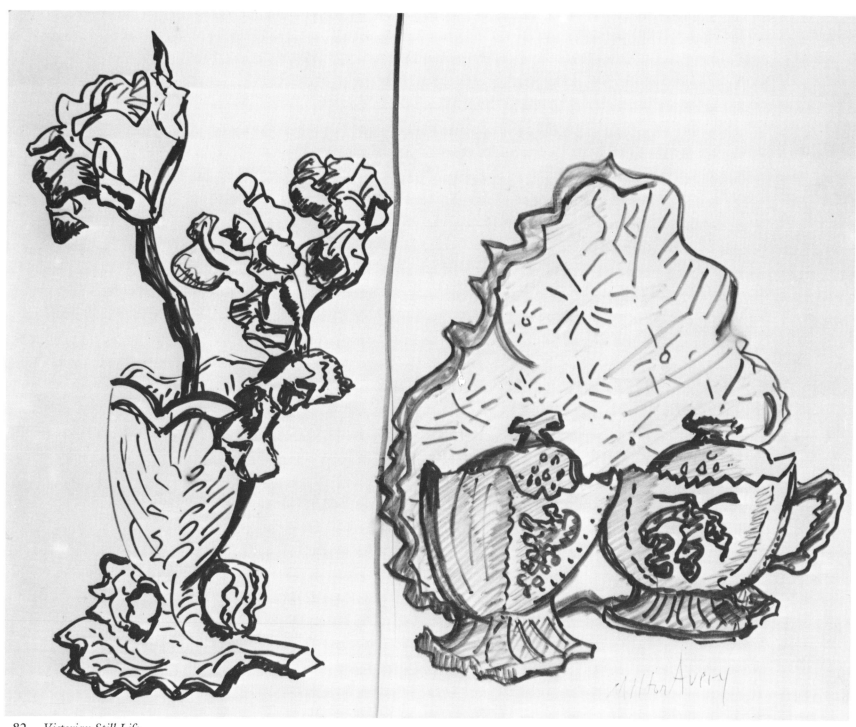

82. *Victorian Still Life*

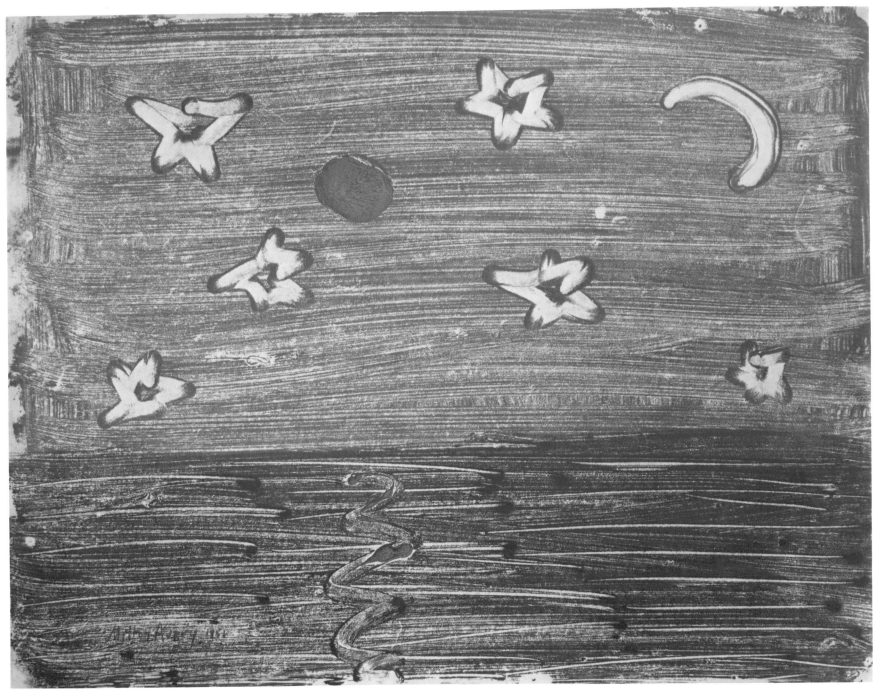

83. *Rosy Moon*

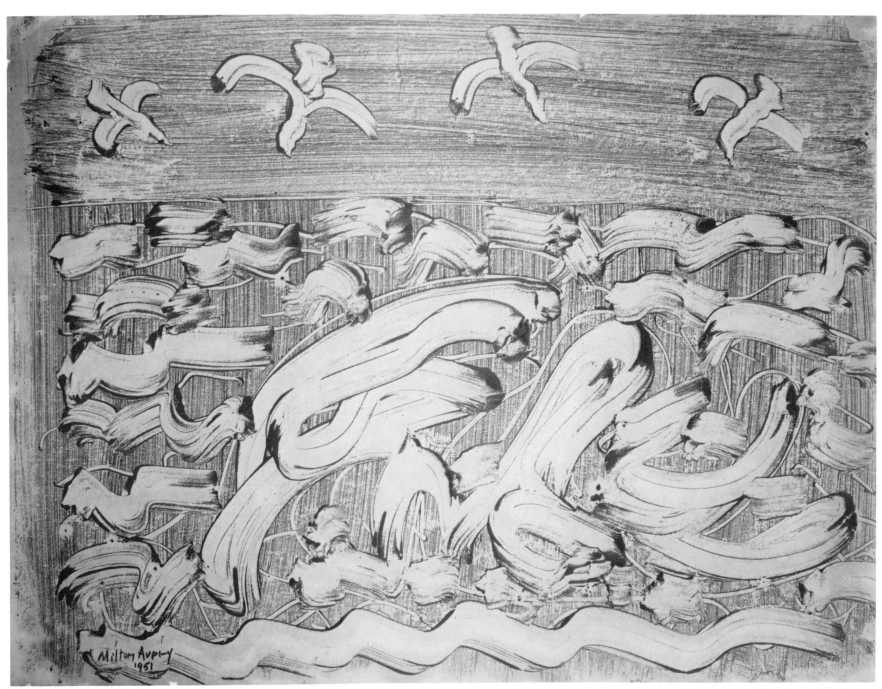

84. *Birds with Ruffled Sea*

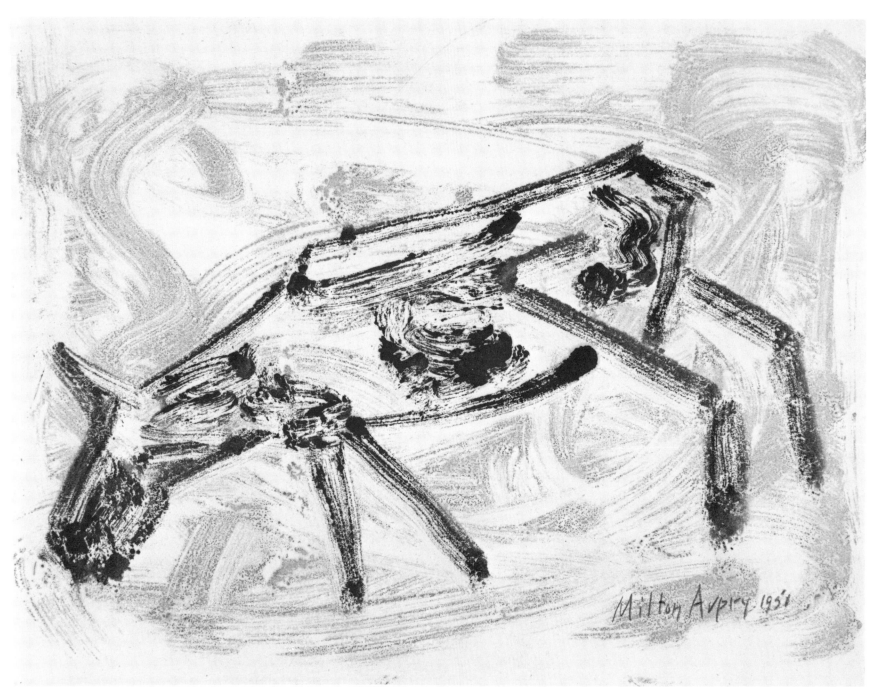

85. *Grazing Animal—Gray*

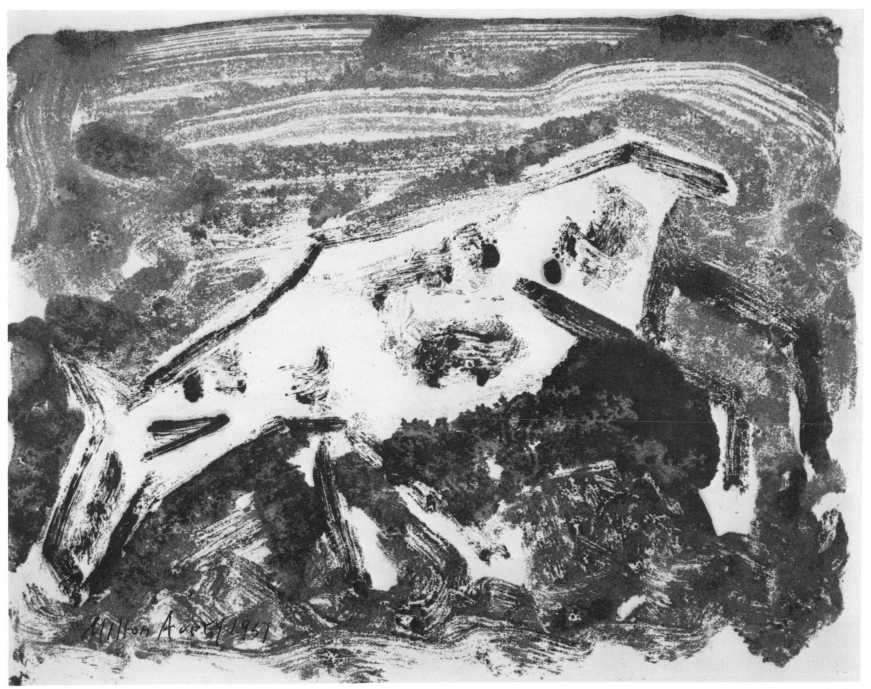

86. *Grazing Animal*

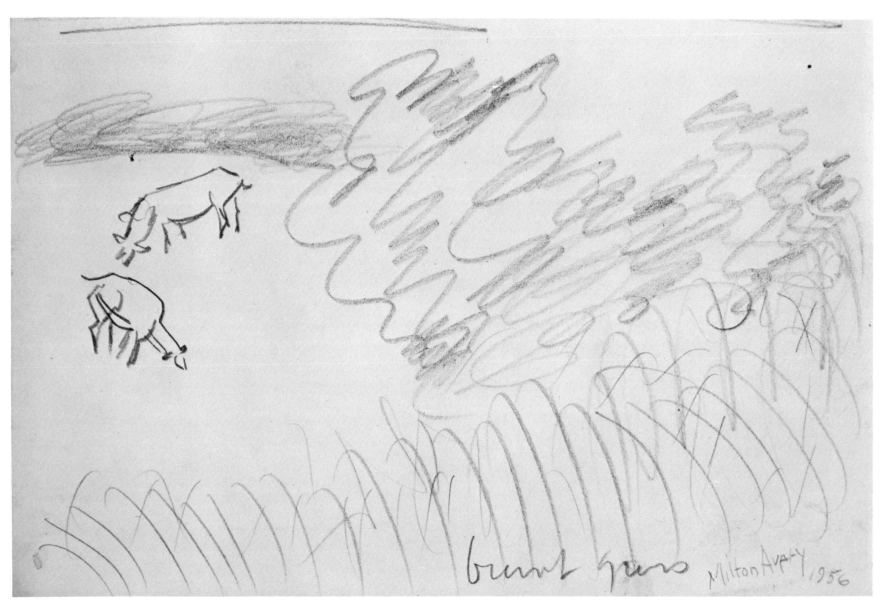

burnt grass Milton Avery 1956

87. *Burnt Grass*

88. *Dog and Prey*

89. *Afghans*

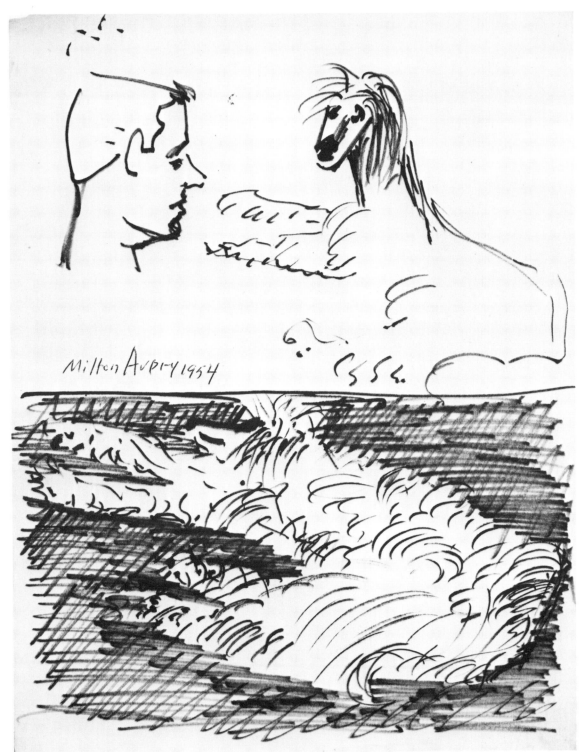

Milton Avery 1954

90. *More Afghans*

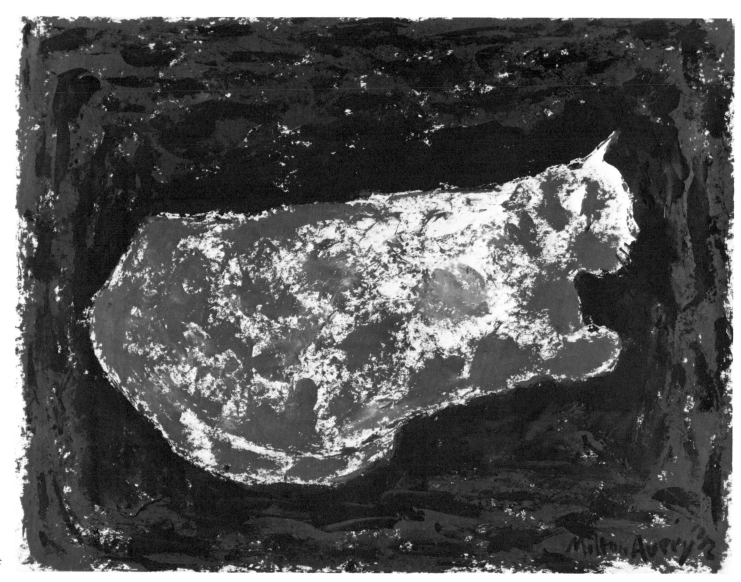

91. *Contented Cat*

92. *Visiting Cat*

93. *Roosting Birds*

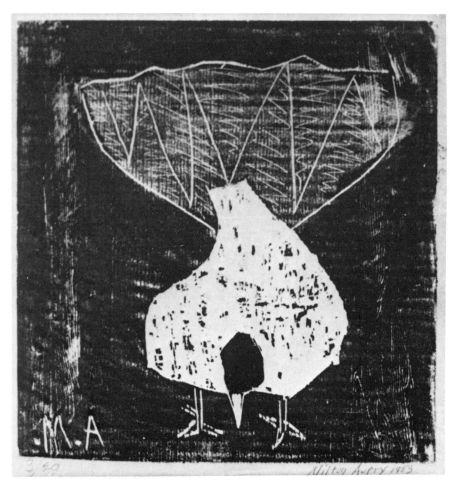

94. *Fantail Pigeon*

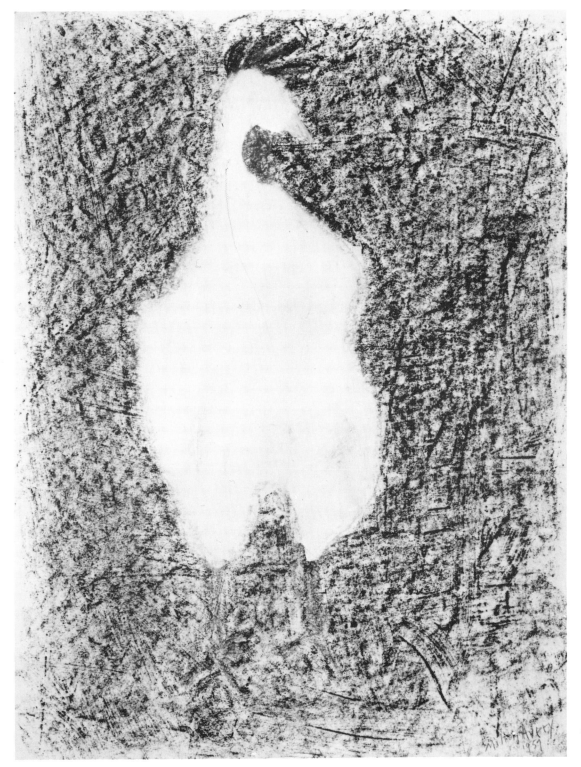

95. *Rooster*

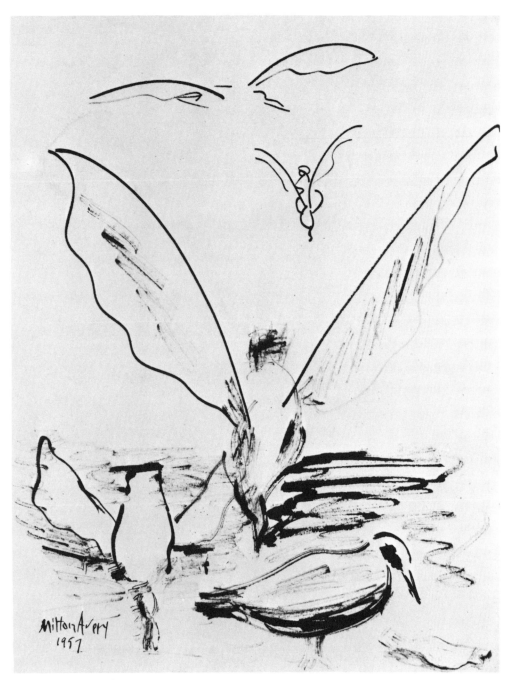

96. *Diving Gulls*

97. *Farmyard*

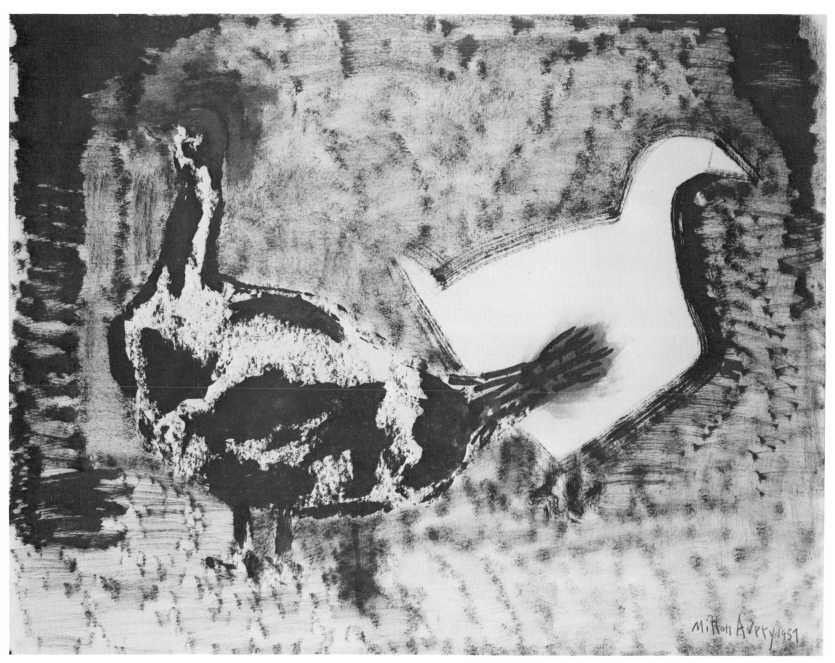

98. *Strutting*

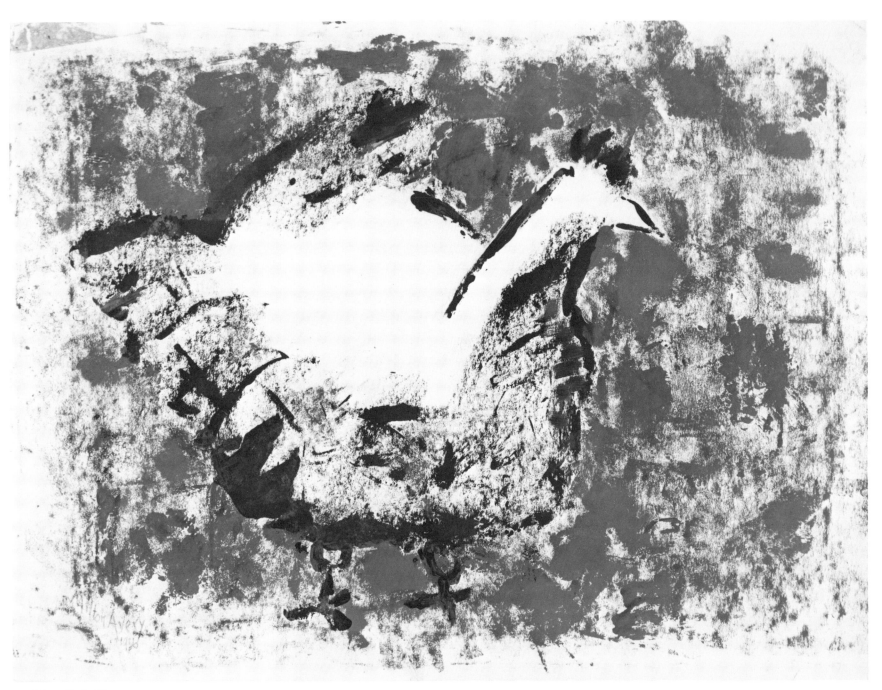

99. *Cocky Hen*

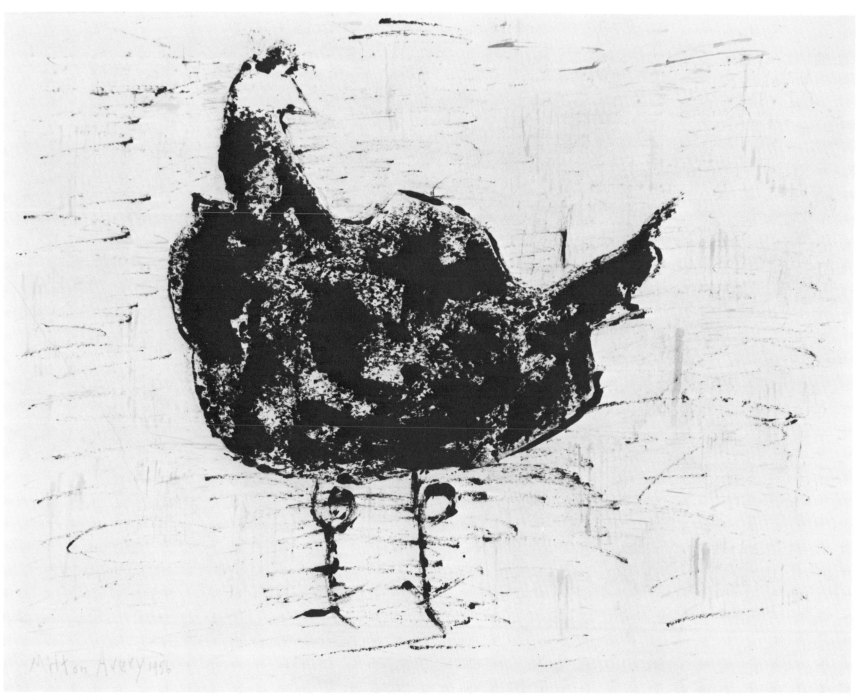

100. *Alert Chicken*

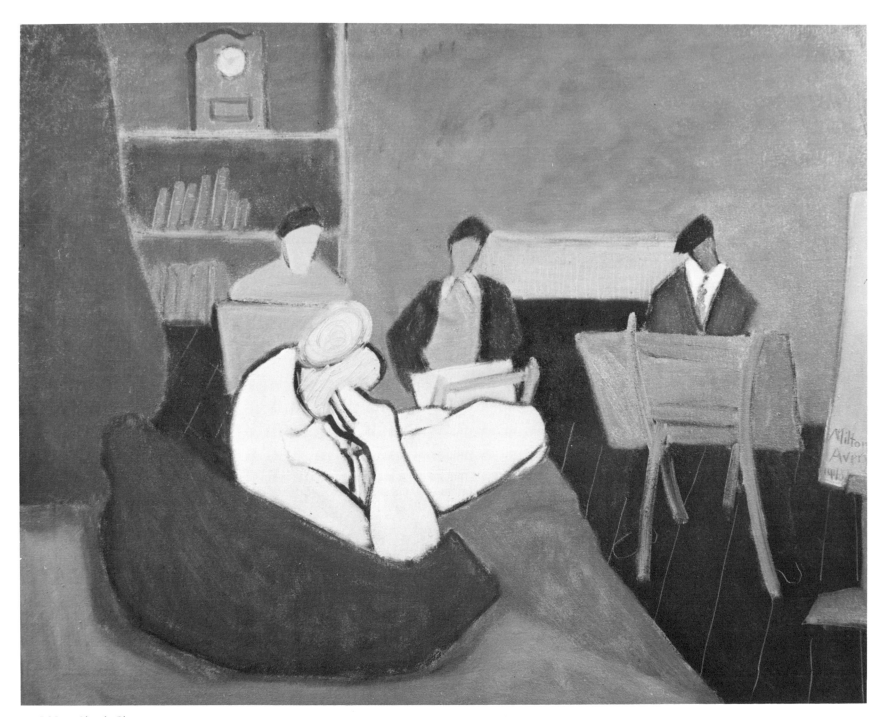

101. *Sketch Class*

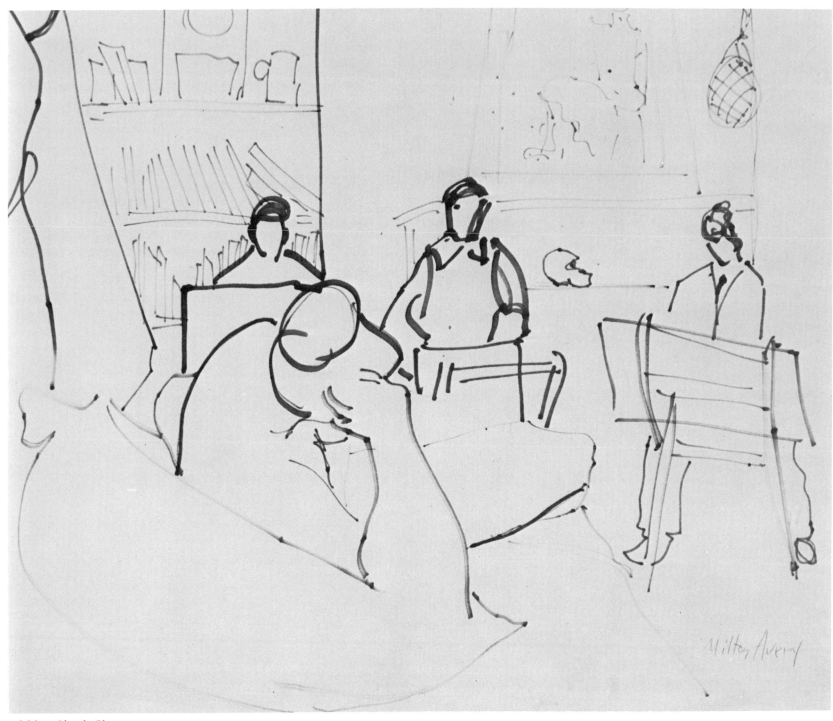

102. *Sketch Class*

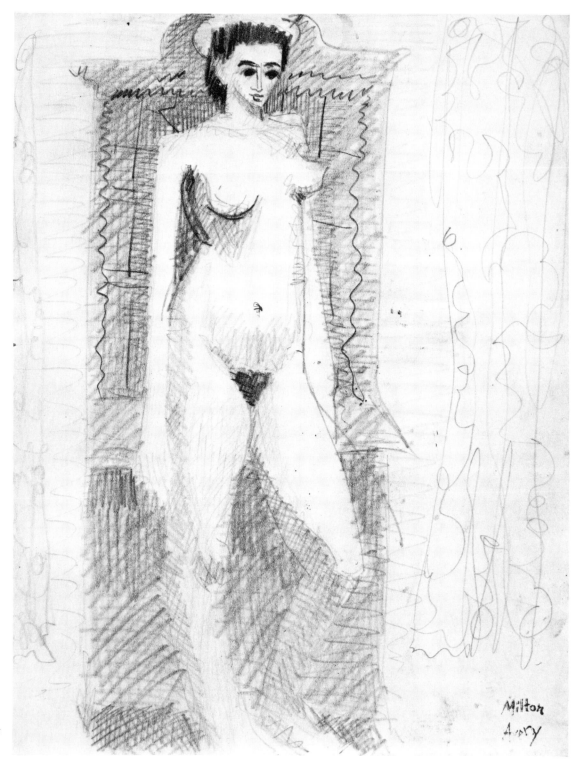

103. *Standing Nude*

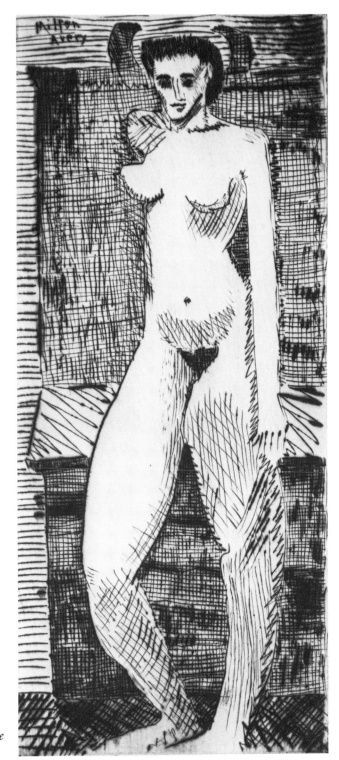

104. *Young Girl Nude*

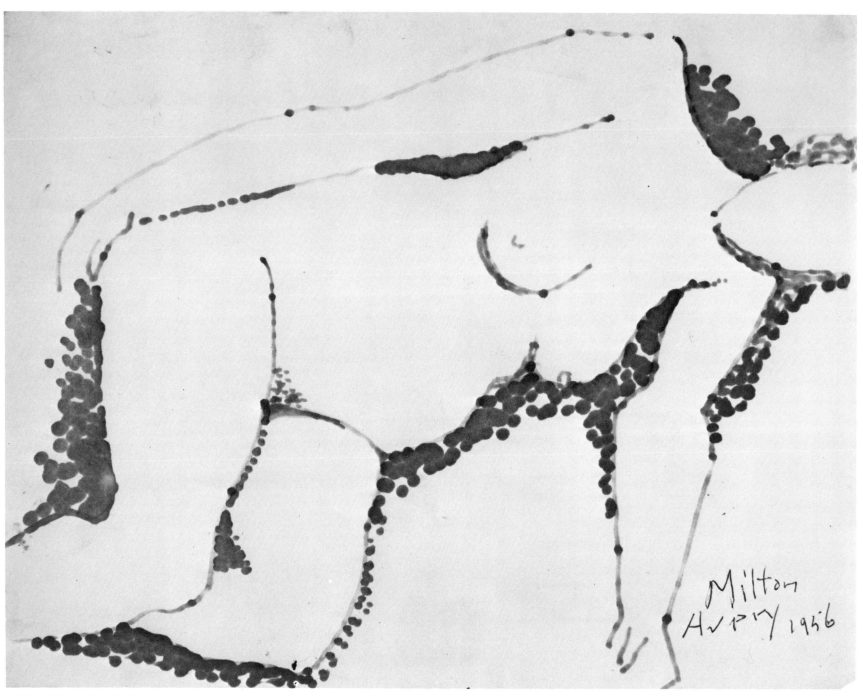

105. *Recumbent Nude*

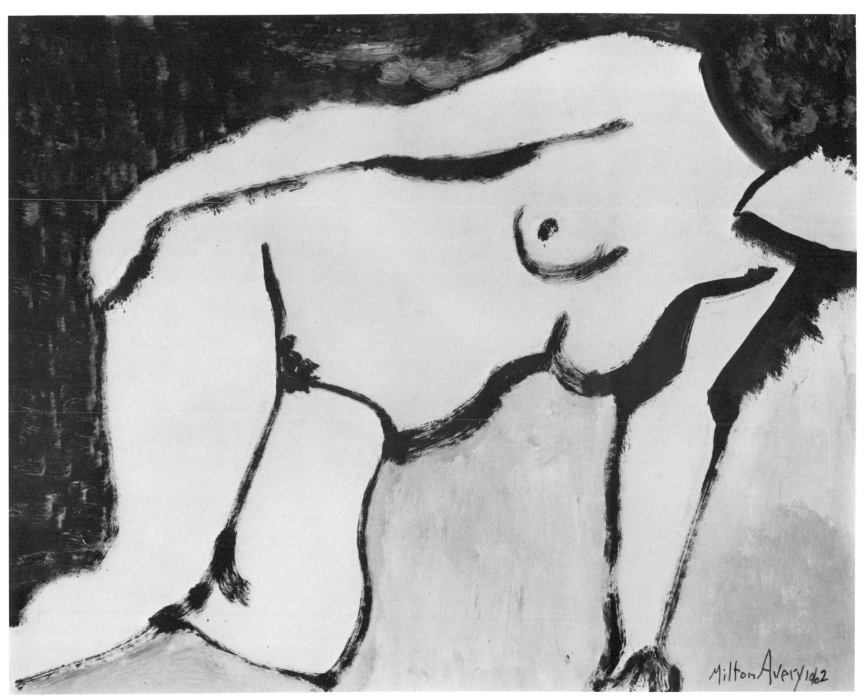

106. *Nude Reclining*

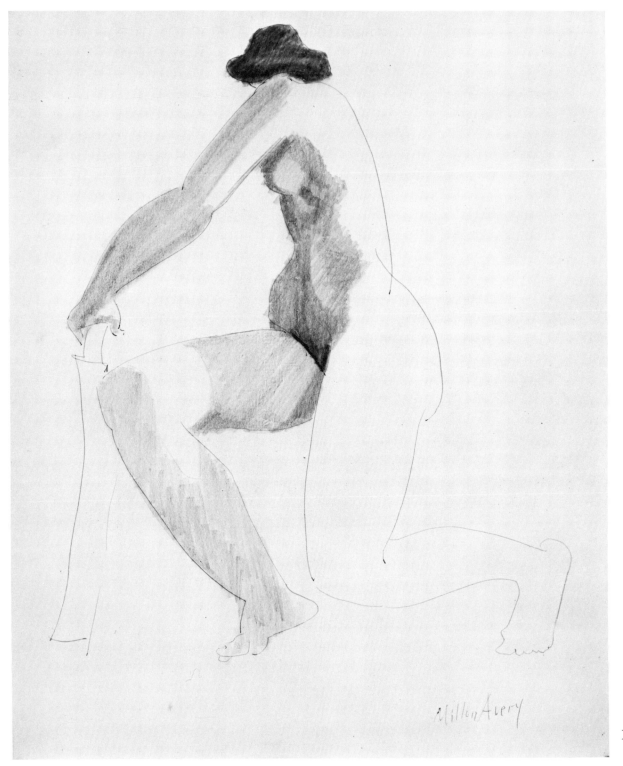

107. *Nude Kneeling*

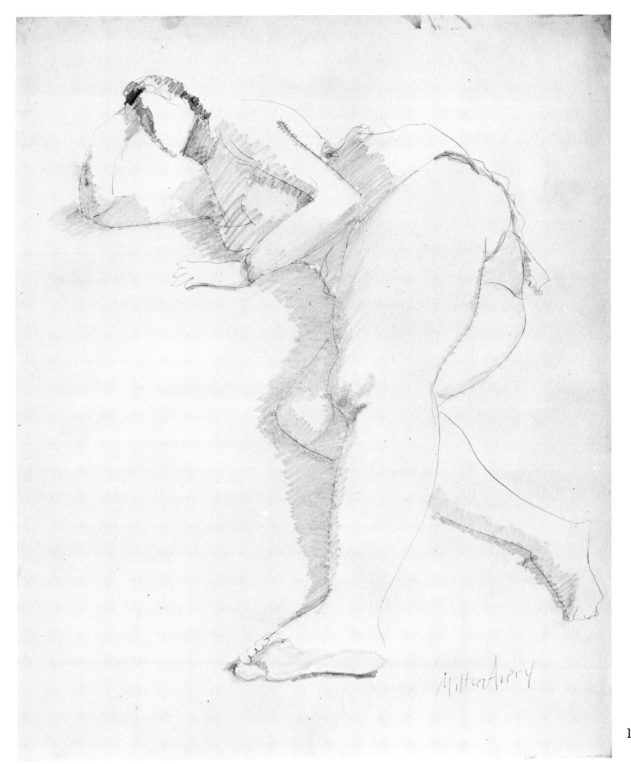

108. *Big Woman*

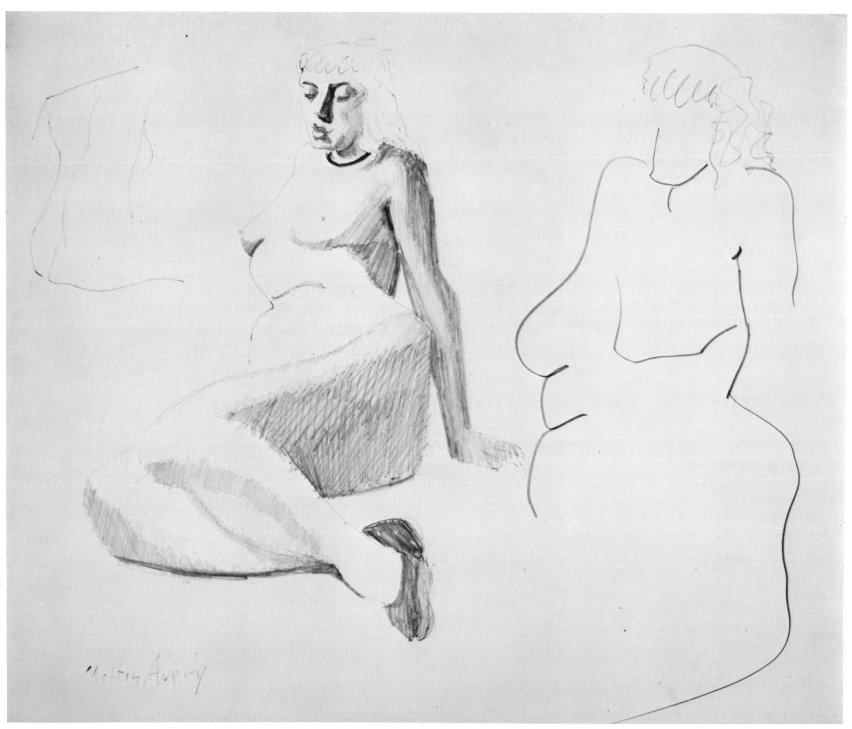

109. *Sulky Nude*

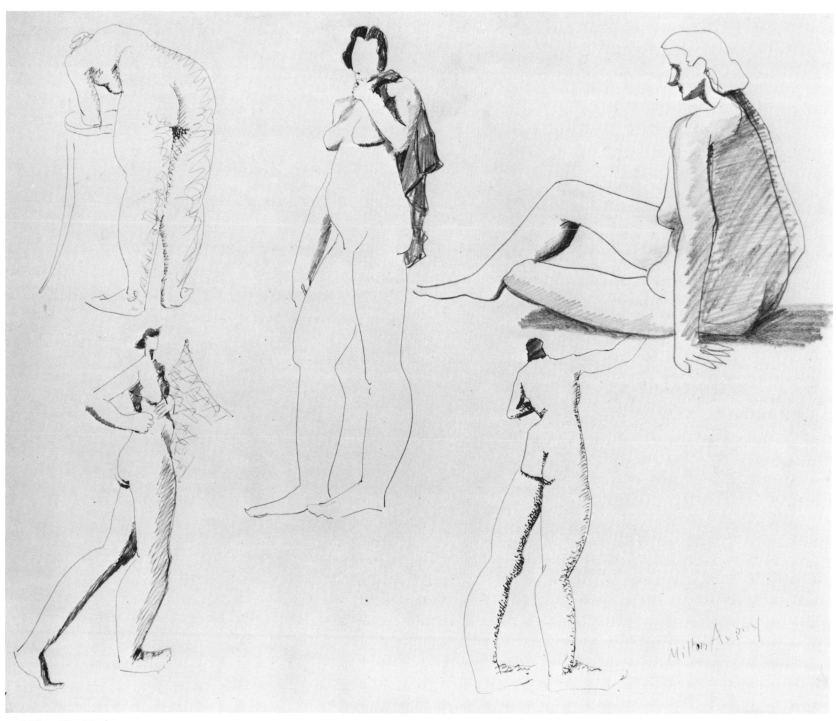

110. *Five Nudes*

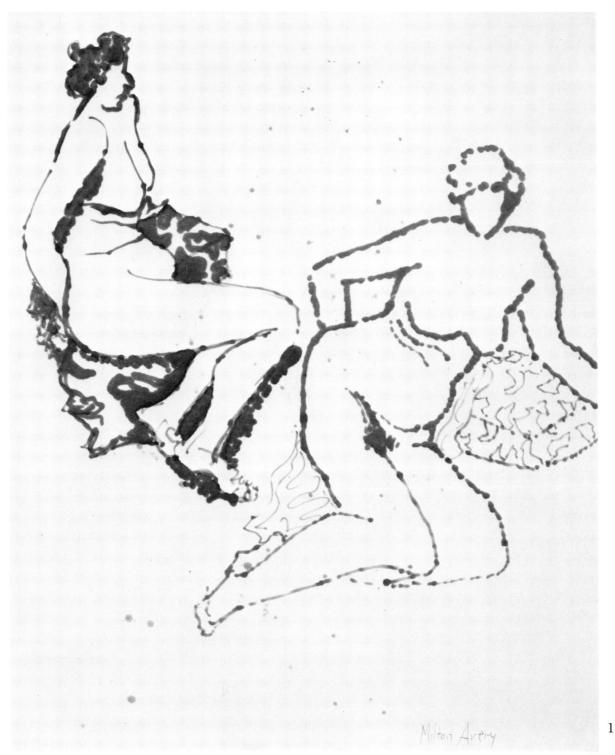

111. *Double Nude*

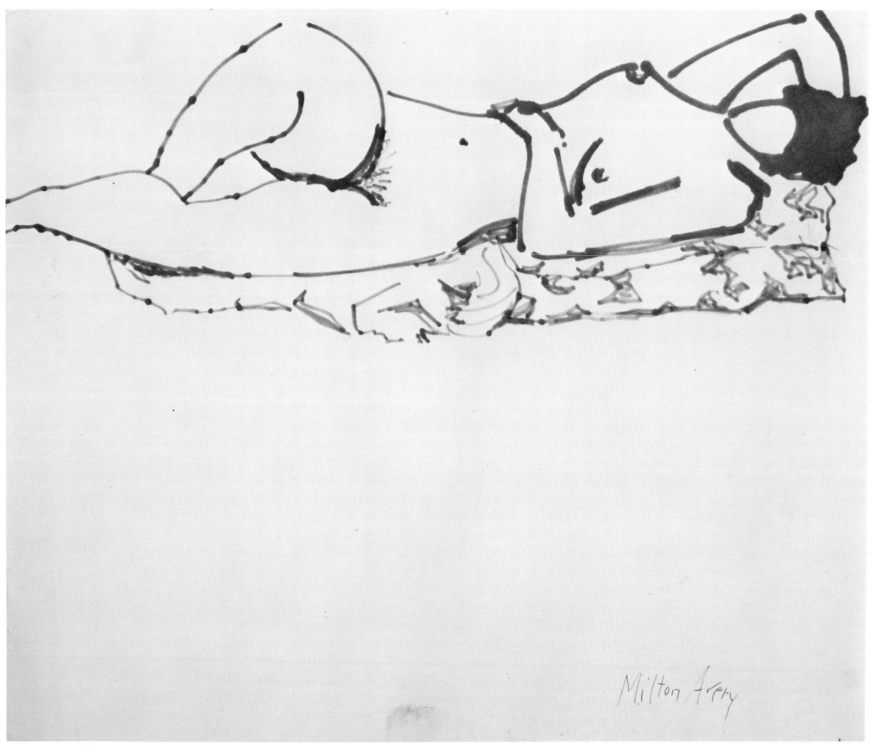

112. *Reclining Nude*

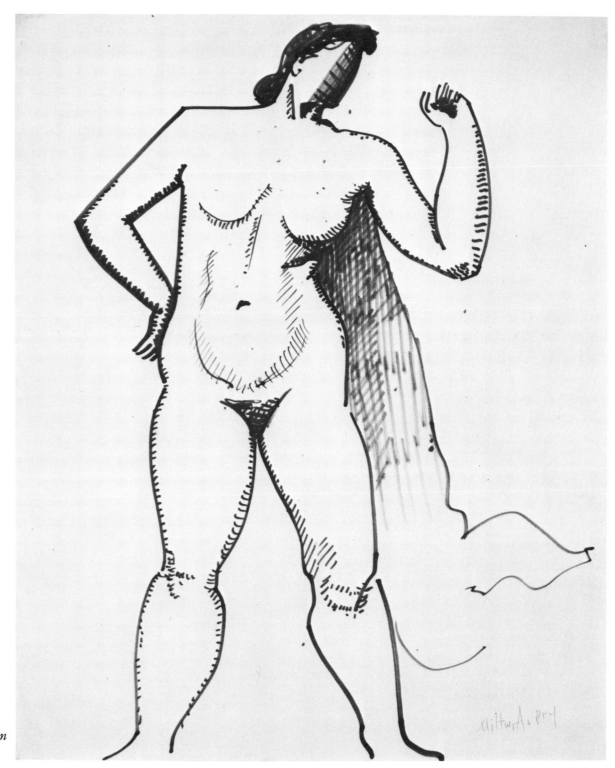

113. *Powerful Woman*

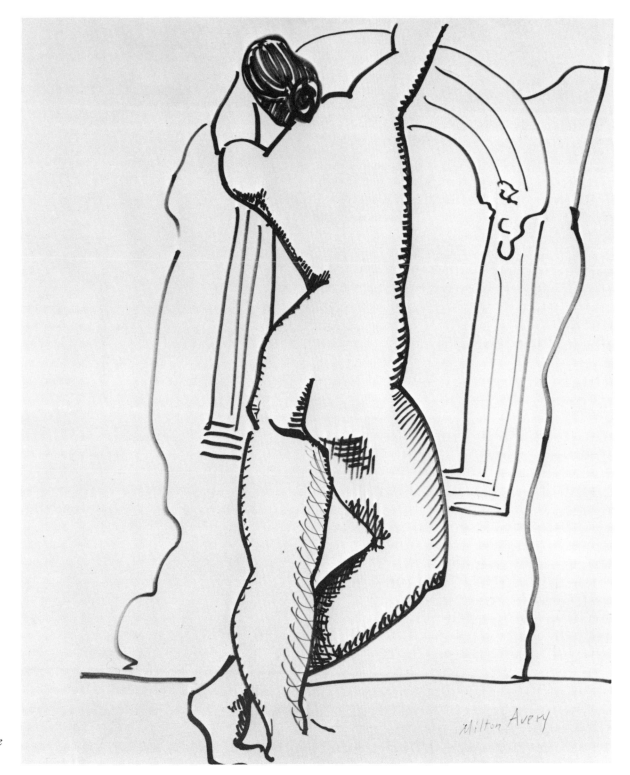

114. *Sturdy Nude*

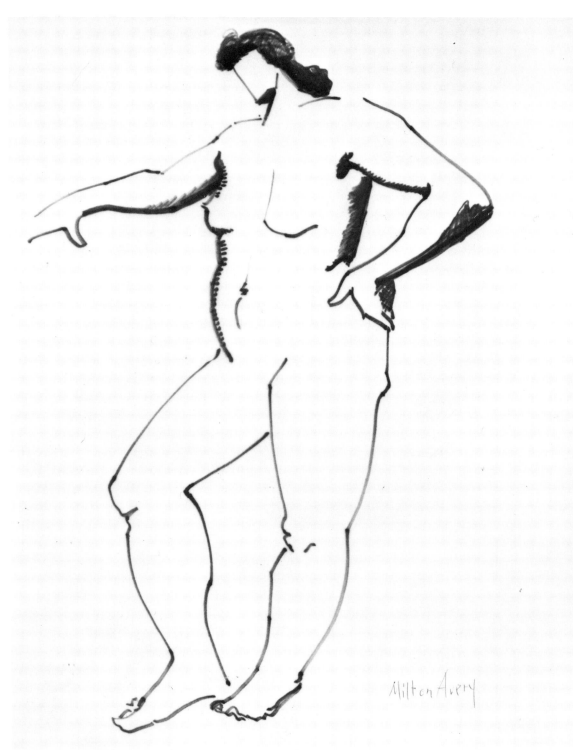

115. *Monumental Woman*

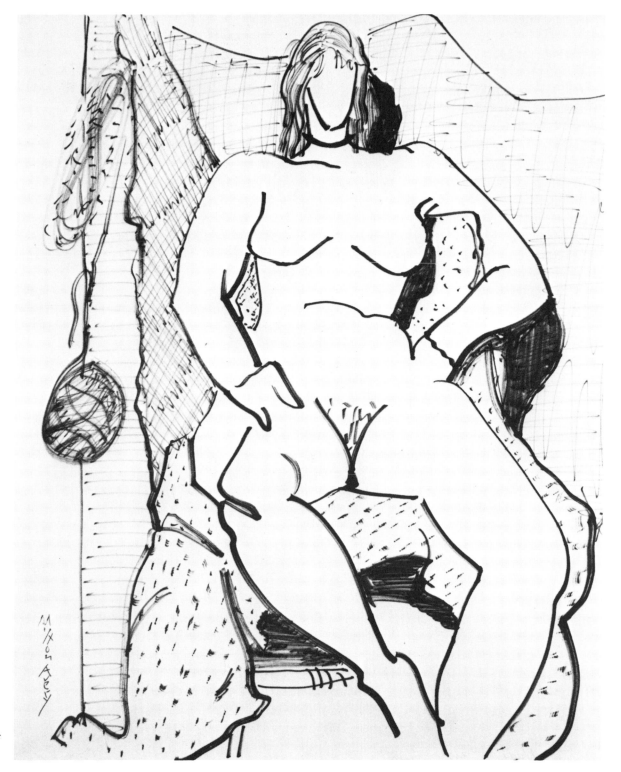

116. *Proud Nude*

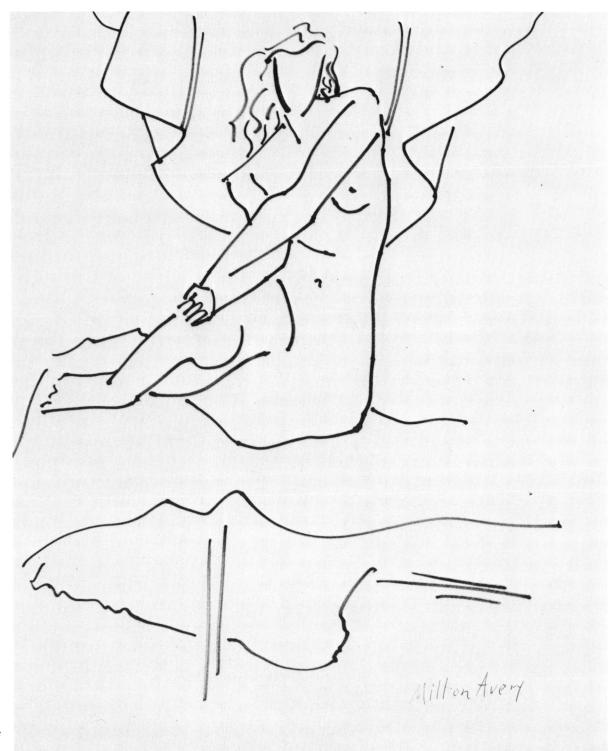

117. *Shy Nude*

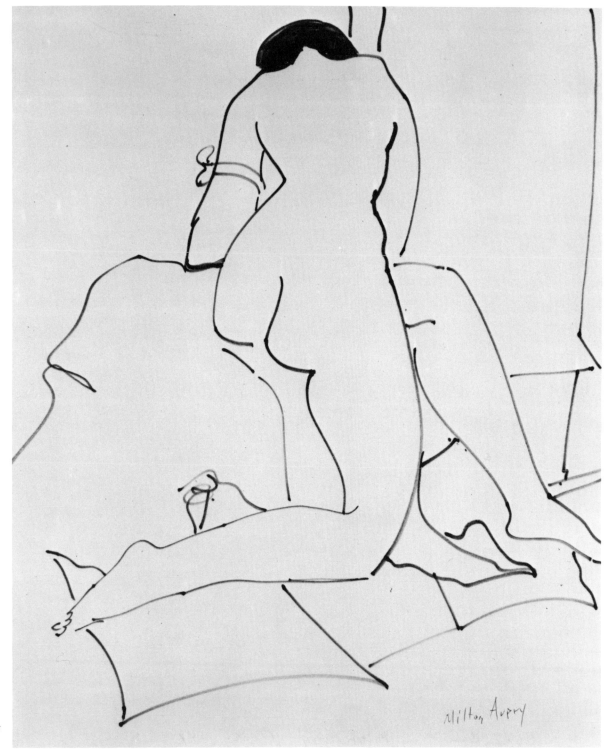

118. *Kneeling Nude*

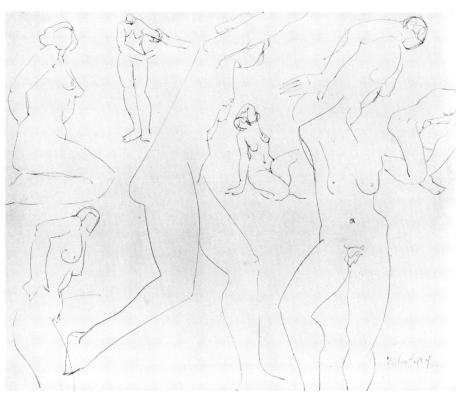

119. *Many Sketches*

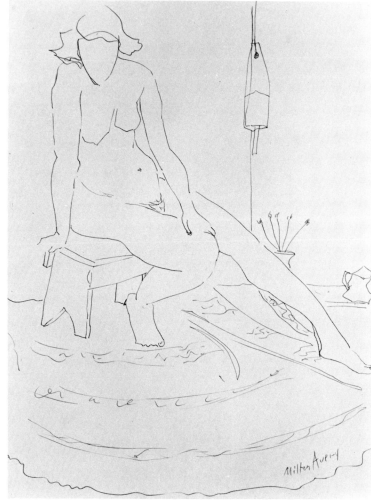

120. *Seated Nude*

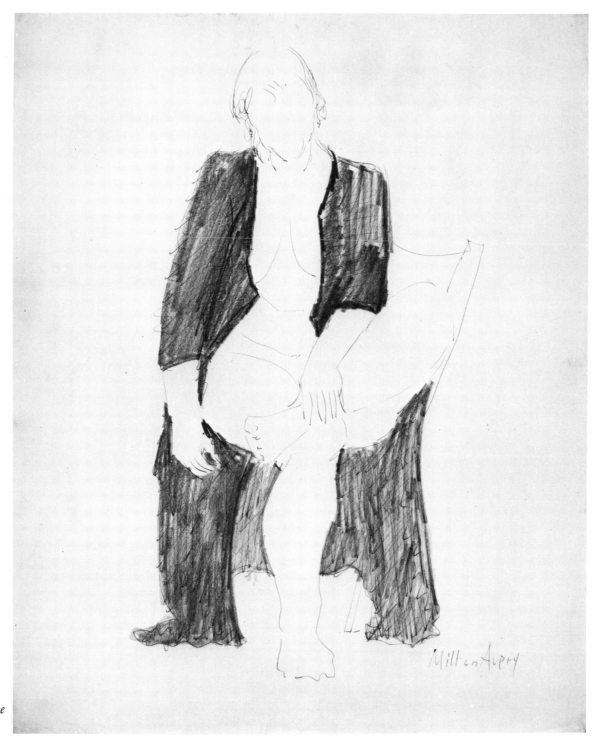

121. *Black Robe*

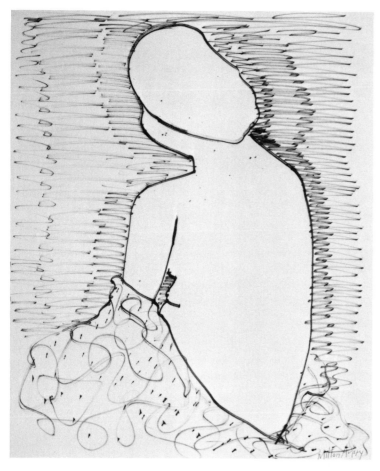

122. *Beautiful Back*

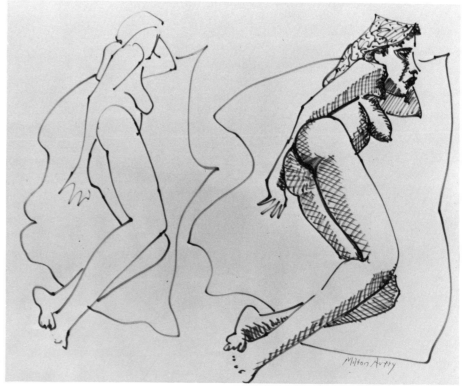

123. *Two Nudes Resting*

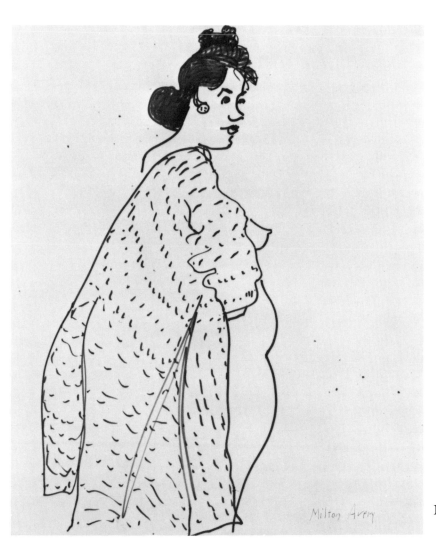

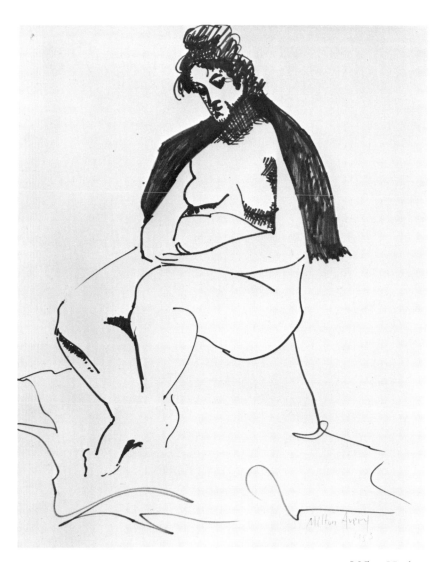

125. *Nude*

124. *Nude with Robe*

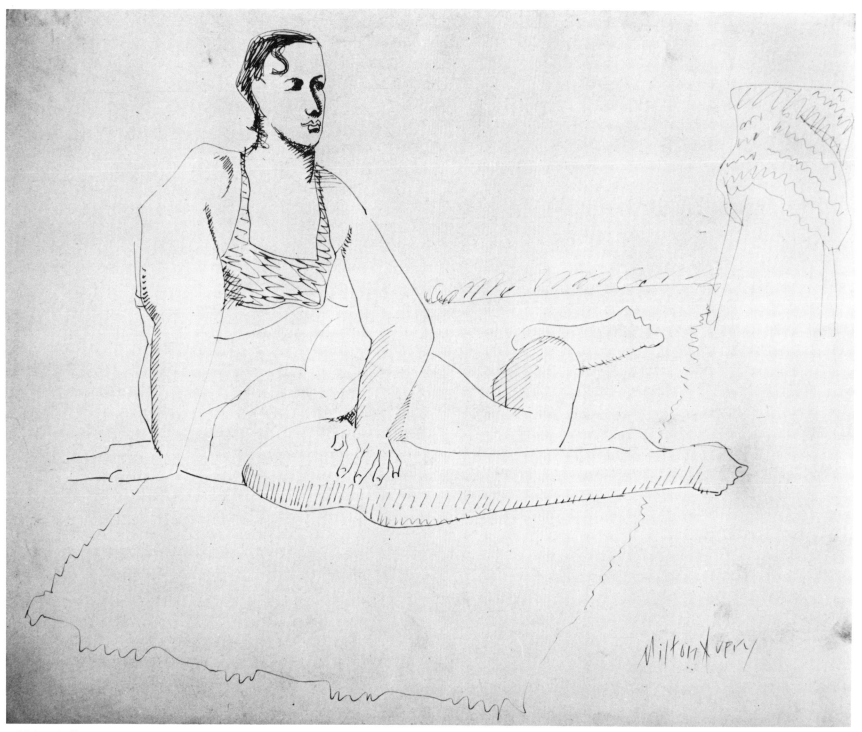

126. *Stella*

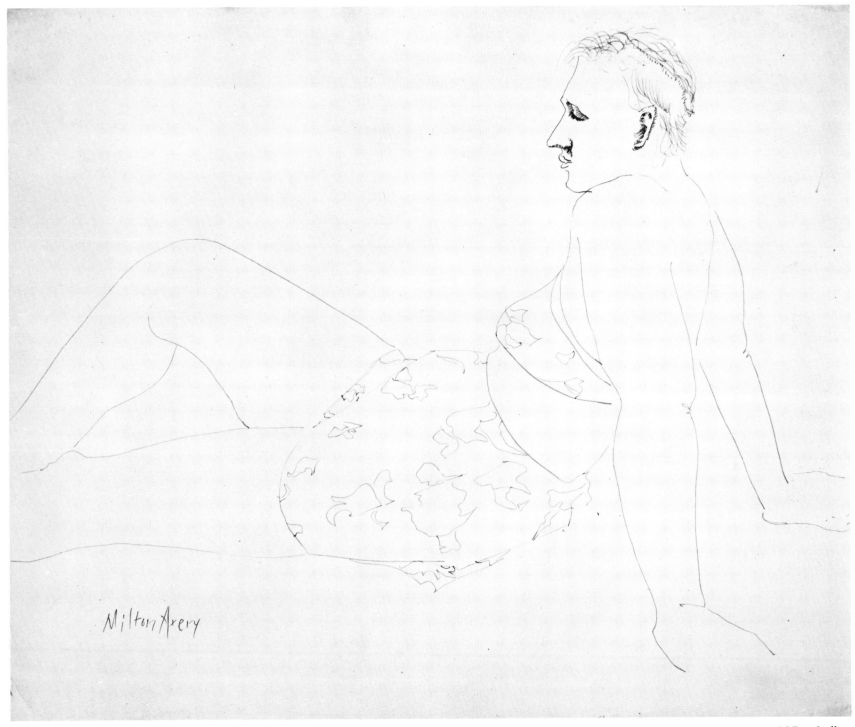

127. *Stella*

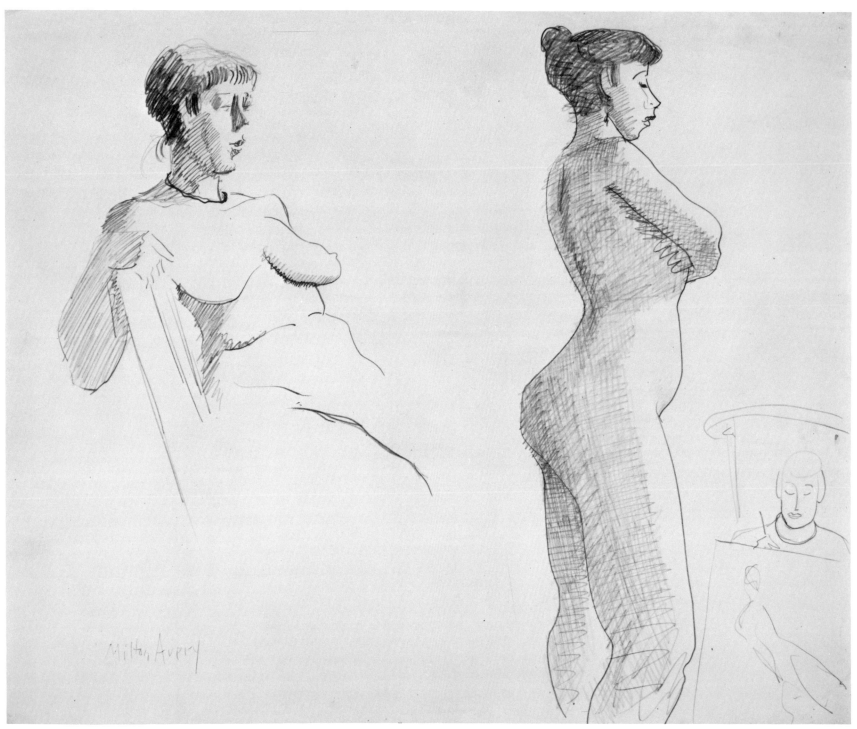

128. *Posing*

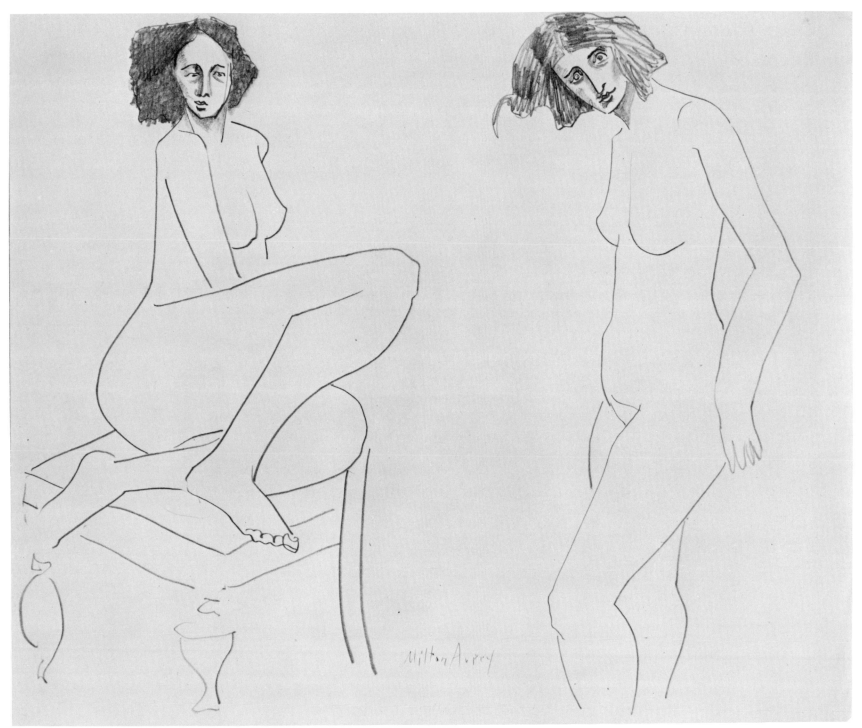

129. *Disturbed Nude*

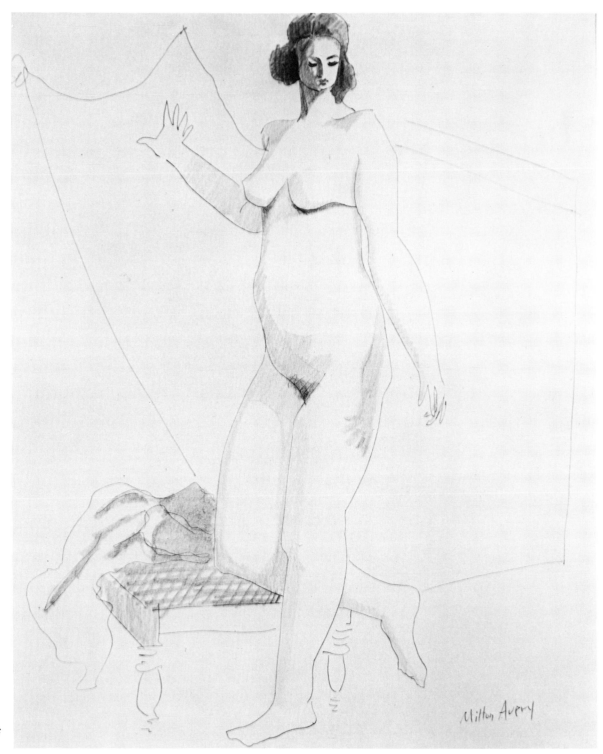

130. *Nude on Bended Knee*

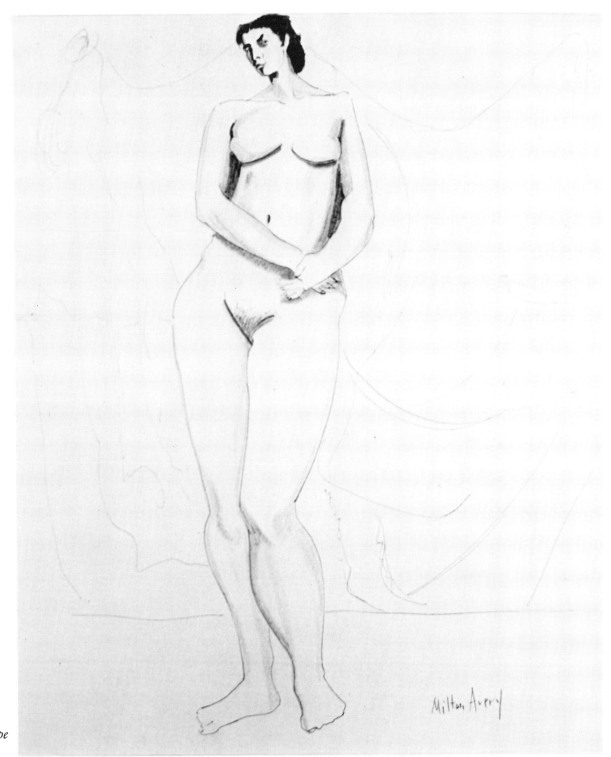

131. *Nude with Drape*

All of Sally Avery's undocumented quotations derive from a series of interviews that date back to 1973. A taped discussion with her on August 20, 1973, and notes recording informal conversations in 1982 and 1983 provided historical background information as well as insight into Milton Avery's working procedures and attitudes.

1. Mark Rothko, Memorial Address, New York Ethical Culture Society, January 7, 1965.

2. Barbara Haskell, *Milton Avery* (New York: Harper & Row, 1982), p.80.

3. Hilton Kramer, *Milton Avery Paintings 1930–1960* (New York: Thomas Yoseloff, 1962).

4. Hilton Kramer, "Milton Avery," *New York Times Magazine,* August 29, 1982.

5. See note 2.

6. Adolph Gottlieb, quoted by Charlotte Willard, "In the Art Galleries," *New York Post,* January 10, 1965, p.46.

7. The Whitney Museum of American Art branch in Fairfield County exhibition, Milton Avery on Paper, Stamford, Connecticut. An exhibition of watercolors and monotypes, September 10–November 3, 1982.

8. Sally Avery, 1982.

9. Sally Avery, 1973.

10. Clement Greenberg, a 1958 article reprinted in his *Art and Culture— Critical Essays* (Boston: Beacon Press, 1961), p.201.

11. Sally Avery, quoted in the catalogue for the exhibition, Milton Avery— Major Works, Boca Raton Center for the Arts, Boca Raton, Florida, January 5–29, 1982.

12. Sally Avery, 1982.

13. Sally Avery, 1983.

14. Haskell, p.184.

15. Haskell, p.13.

16. Haskell, pp.18–19. The drawing and painting are reproduced in illustrations 1 and 2.

17. John Sloan, quoted by Carter Ratcliff in the catalogue for the exhibition, The Gloucester Years, Borgenicht Gallery, New York, February 6–March 4, 1982.

18. Sally Avery, 1982.

19. Albert Pinkham Ryder, "Paragraphs from the Studio of a Recluse," *American Art, 1700–1960, Sources and Documents,* J. W. McCoubrey, ed. (Prentice-Hall, Englewood Cliffs, N.J., 1965), p.187.

20. Haskell, p.27.

21. Milton Avery, in the catalogue for the exhibition, Contemporary American Painting, College of Fine and Applied Art, University of Illinois, Urbana, February 26–April 2, 1951, pp.158–159.

22. Sally Avery, quoted in the catalogue for the exhibition, Milton Avery and His Friends, Borgenicht Gallery, New York, January 28–February 24, 1978.

23. Marsden Hartley, quoted in the catalogue for the exhibition, Milton Avery and the Landscape, William Benton Museum of Art, University of Connecticut, Storrs, March 15–April 16, 1976.

24. Interview with Sally Avery, 1982. On a number of occasions Rothko stated that he "hated to draw."

25. Willard, p.46.

26. Rothko, Memorial Address.

27. Edward Alden Jewell, "Art in Review," *New York Times,* April 18, 1932, p.13.

28. Haskell, p.53.

29. Haskell, p.146.

30. Greenberg, p.201.

31. Haskell, p.133.

32. See note 11

33. Chris Ritter, "A Milton Avery Profile," *Art Digest,* December 1, 1952, p.11.

34. Sally Avery, 1982.

35. Ritter, p.28.

36. Kramer, *New York Times Magazine,* p.42.

37. Henry Geldzahler, foreword to the catalogue for the exhibition, The Sea by Milton Avery, Louise E. Thorne Memorial Art Gallery, Keene State College, Keene, New Hampshire, September 26–October 16, 1971.

38. Haskell, p.129.

39. Milton Avery, in the catalogue for the exhibition, Contemporary American Painting and Sculpture, College of Fine and Applied Art, University of Illinois, Urbana, February 26–April 2, 1959, p.192.

40. Haskell, p.150. This painting is illustrated in color, plate 122.

Dimensions are listed in inches with height preceding width.

1. *Avery with Beret,* 1951
 Flobrush 11 × 8¹/₂
 Joan and Gabor Peterdi

2. *Drifting Sea Gull,* 1957
 Ink wash 20 × 26
 Courtesy Alpha Gallery

3. *The Letterwriter,* 1931
 Lithocrayon 8 × 8
 Private collection

4. *Woman with Green Face,* 1932
 Oil on canvas 23 × 24
 Mr. and Mrs. Bernard Livingston

5. *My Wife Sally,* 1934
 Drypoint 5⁹/₁₆ × 8⁵/₁₆

6. *Portrait of Mark Rothko,* 1933
 Oil on canvas 22¹/₂ × 16
 Museum of Art, Rhode Island School of Design.

7. *Mark Rothko,* ca. 1933
 Pencil 11 × 9
 Dr. and Mrs. Marvin Klein

8. *Nine Maine Sketches,* 1948
 Flobrush 14 × 17

9. *Birds and Stars,* 1952
 Mixed media drawing 11 × 8¹/₂
 Private collection

10. *Resting,* 1950
 Flobrush 8¹/₂ × 11
 Leslie and Mark Grossman

11. *Conversation,* 1963
 Flobrush 8¹/₂ × 11
 Paige Chernow

12. *Lily,* ca. 1927/1928
 Lithocrayon 11 × 8¹/₂

13. *Sally's Friend,* ca. 1927/1928
 Lithocrayon 11 × 8¹/₂

14. *Female Artist,* ca. 1927/1928
 Lithocrayon 11 × 8¹/₂

15. *Visitor,* ca. 1927/1928
 Lithocrayon 11 × 8¹/₂

16. *Lullabye,* 1932/1933
 Ink 11 × 8¹/₂

17. *First Born,* 1932/1933
 Ink 11 × 8¹/₄

18. *Maternity,* 1932/1933
 Lithocrayon 11 × 8¹/₂

19. *Doting Mother,* 1932/1933
 Lithocrayon 11 × 8¹/₂

20. *Nursing Baby,* 1932/1933
 Ink 11 × 8¹/₂

21. *Striped Blouse,* 1932/1933
 Lithocrayon, 11 × 8¹/₂

22. *Sally with Beret,* 1939
 Drypoint 8 × 6³/₈

23. *Artist's Daughter*
 Pencil and lithocrayon 17 × 14

24. *Gallery Woman*
 Pencil 17 × 14

25. *Belle Gross,* 1942
 Pencil 11 × 8¹/₂

26. *Hatted Woman*
 Lithocrayon 11 × 8¹/₂
 Mr. and Mrs. Herbert Lerner

27. *Hatted Woman*
 Pencil 6¹/₂ × 4¹/₂ on 11 × 8¹/₂

28. *Belle Gross*
 Lithocrayon 17 × 14

29. *Dolia*
 Flobrush 17 × 14
30. *Dolia*, 1946
 Flobrush
 Courtesy Alpha Gallery
31. *Head of March*, 1951
 Lithograph 12 × 9
32. *March*, 1951
 Lithocrayon 11 × 8½
33. *March in Brown*, 1954
 Oil on canvas 44 × 32
 Mr. and Mrs. Philip Cavanaugh
34. *March in Deep Brown Dress*
 Pencil 8½ × 3½
 David Stang
35. *Coney Island*, 1933
 Oil on canvas 26 × 33
 Milton Avery Trust
36. *Coney Island Sketches*, 1931
 Pencil 17 × 14
 Milton Avery Trust
37. *Four Beach Studies*
 Pencil 8½ × 11
38. *Man with Pipe* (Adolph Gottlieb)
 Pencil 11 × 8½
39. *Beach Studies*
 Pencil 11 × 8½
40. *Eilshemius*
 Oil on canvas 36 × 28
 Alfred Newman
41. *Eilshemius*
 Pencil 11 × 8½
42. *Checker Players*, 1938
 Oil on canvas 28 × 36
 Mr. and Mrs. Weingrow
43. *Checker Players*, ca. 1937/1938
 Pencil 8½ × 11
44. *Visitor*
 Pencil 11 × 8½
45. *Woman with Folded Arms*
 Pencil 17 × 14
 Annelott and Jurgen Zech
 Cologne, West Germany

46. *Little Worker*
 Ink 11 × 8½
47. *March in Costume*
 Ink 11 × 8½
48. *Summer Reader*, 1950
 Oil on canvas 34 × 44
 Mrs. Ruth Bernstein
49. *Summer Sketches*, ca. 1950
 Pencil 17 × 14
50. *Sleeping Girl*, ca. 1930
 Ink 11⅛ × 14⅛
51. *March Reading*
 Ink 8½ × 11
 Lou and Paul Hicks
52. *Victorian Interior*, 1949
 Flobrush 8½ × 11
53. *Girl Reading*, 1949
 Flobrush 8½ × 11
 Private collection
54. *Six Sketches*, 1949
 Flobrush 14 × 17
55. *Bather Indoors*, 1949
 Ink 17 × 14
56. *Female Artist*, 1960
 Ink 17 × 14
 Courtesy Christies, New York
57. *Kneeling*
 Ink 11 × 8½
58. *Dancer*
 Pencil 14 × 17
59. *Lavender Settee*, 1961
 Oil on canvas 28 × 36
 Mr. and Mrs. F. E. Solomon
60. *New Friends on Old Sofa*, 1961
 Ink 8½ × 11
 Wells, Rich, Greene, Inc.
61. *Mountain Landscape*, 1962
 Oil on paper 23 × 35
 Courtesy Alpha Gallery
62. *Rocky Terrain*, 1938
 Ink 14 × 17
 Courtesy Connecticut Fine Arts
63. *Inlets*, 1957

Flobrush 11 × 8½
Private collection

64. *Jagged Rocks*, 1947
Flobrush 17 × 14

65. *Pines by Sea*
Flobrush 8 × 14

66. *Tree and Rocks*
Flobrush 8¼ × 13¾

67. *Trail and Trees*
Flobrush 5 × 8½

68. *Dunes and Sea*
Flobrush 5 × 8½

69. *Seven Sketches*, 1950
Pencil and Flobrush 14 × 14
Courtesy Connecticut Fine Arts

70. *Pale Rocks*, 1949
Flobrush 17 × 14

71. *Two Landscapes*
Flobrush 17 × 14
Private collection

72. *Three Seascapes*
Flobrush 17 × 14

73. *Many Colored Rocks*
Flobrush 14 × 17

74. *Sea Gulls by the Sea*
Flobrush 14 × 17

75. *Nudes on the Rocks*, 1948
Flobrush 14 × 17
Mr. and Mrs. Arthur Fribourg

76. *Surf and Rocks*, 1948
Flobrush 14 × 17

77. *Open Door*, ca. 1954
Flobrush 11 × 8½

78. *Towering Trees*, 1954
Crayon 24 × 7½
Courtesy Crispo Gallery

79. *Green Sea Gray Sky*, 1958
Crayon 23 × 35
Courtesy Borgenicht Gallery

80. *Tender Dunes*, 1960
Pencil and ink

81. *Dune Grasses*, 1958
Felt Pen 8½ × 11

82. *Victorian Still Life*, 1949
Flobrush 14 × 17
Courtesy Connecticut Fine Arts

83. *Rosy Moon*, 1951
Monotype 18 × 24
Courtesy A.A.A. Gallery

84. *Birds with Ruffled Sea*, 1951
Monotype 18 × 24
Courtesy A.A.A. Gallery

85. *Grazing Animal—Gray*, 1951
Monotype 8½ × 11
David Chenok

86. *Grazing Animal*, 1951
8½ × 11
Perrin Chernow

87. *Burnt Grass*, 1956
Pencil 5½ × 8½
Private collection

88. *Dog and Prey*
Pencil 8½ × 11

89. *Afghans*, 1954
Flobrush 8½ × 11

90. *More Afghans*, 1954
Flobrush 11 × 8½

91. *Contented Cat*, 1956
Oil on paper 17 × 22
Courtesy Connecticut Fine Arts

92. *Visiting Cat*, 1951
Ink 8½ × 11
Courtesy Connecticut Fine Arts

93. *Roosting Birds*
Ink 11 × 8½

94. *Fantail Pigeon*, 1953
Woodcut 10⅛ × 9¾

95. *Rooster*, 1957
Oil crayon 22 × 17

96. *Diving Gulls*, 1957
Flobrush 11 × 8½

97. *Farmyard*, 1947
Flobrush 14 × 17
Mrs. Susanna Neilson

98. *Strutting*, 1957
Oil on paper 19¼ × 24½